WELCOME TO BODY ART

PICTURE: TOM BROADBENT

Today, modi[...] than an ear[...] tattooed on your shoulder.

Thanks to technological developments – and the tireless efforts and imagination of artists across the world – time-honoured processes such as scarification and piercing have been refined and taken to unprecedented levels of detail and clarity, allowing body modders to create innovative, distinctive and unforgettable pieces of work.

Body Art is a celebration of this evolving artform, examining the most popular modification processes and giving advice to anyone considering getting their own body enhanced. And in speaking to the world's most famous body artists and tattooists to understand what motivates them, this book will take you under the skin of the scene's biggest players.

CONTRIBUTORS

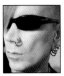

ASHLEY Ashley (Savageskin.co.uk) is one of the UK's most respected photographers of alternative culture, and contributed most of the images in *Body Art*. "I'm drawn towards documenting beauty that's strange or unique, that which falls outside the parameters of 'acceptability' designated by society," he says. Since taking up photography in 1989, Ashley's work, which "vacillates between the art and documentary genres", has been extensively published and selectively exhibited, and is held in both public and private collections.

MIKE MANSFIELD One of the newest members of the *Bizarre* team, Mike designed *Body Art* to one of the most punishing deadlines in publishing history. Shortly after joining *Bizarre*, Mike had a free tattoo courtesy of a videogame publisher, and now has the beginnings of a Japanese-style sleeve on his left arm. Despite the advice of expert branders (see page 92), Mike came back after a recent holiday with the letter 'M' branded on his arse, sizzled into his skin by a drunken mate using a bent coat hanger heated over a campfire.

JAMES DOORNE As Senior Writer of *Bizarre*, James has been suspended by hooks driven through the flesh of his back, spent many an evening lurking in shadowy sex clubs, and worn pendulous fake breasts on a trip to our local boozer – all in the name of journalism, of course. James is Associate Editor and author of most of the features contained in *Body Art*, and has spent six months submerging himself in the world of tattoos, piercings, stretching, branding, implants and scarification.

SHANNON LARRATT Since 1994, Shannon Larratt has been the editor and publisher of Bmezine.com, the largest and oldest full-spectrum body-modification online publication on the planet. He has also published several books, and is an established online author, artist, computer programmer, film producer, and business owner. As well as providing many photographs for *Body Art*, Shannon was also the person who put us in touch with some of the amazing inked and modified people interviewed in this book.

BODY ART CONTENTS

FEATURES

From tattoos and scarification to stretching and extreme body mods, we've got everything you need to know about body art covered…

TATT FACT
Keep a lookout for the tattoo trivia scattered through this book

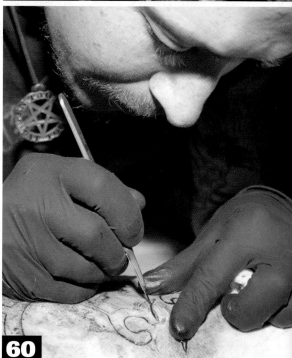

18

60

PICTURES: TOM BROADBENT; ASHLEY/SAVAGESKIN.CO.UK; DORALBA PICERNO

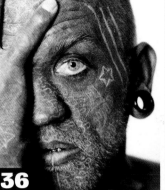

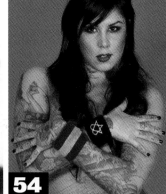

36

54

INKED ICONS

Over the years, *Bizarre* has interviewed some of the biggest names in body modification to understand their motivations and aspirations…

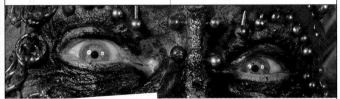

BODY ART

EDITORIAL
Editor David McComb
Associate Editor James Doorne
Features Editor Kate Hodges
Chief Sub Editor Greg Hughes
Staff Writer Denise Stanborough
Editor At Large Alex Godfrey

ART
Art Director Mike Mansfield
Picture Editor Tom Broadbent
Art Director At Large Dave Kelsall

COVER PHOTOS
Ashley/Savageskin.co.uk; Bmezine.com; Byblair.com; Doralba Picerno; James Stafford; Zegrae/Zegrae.co.uk/Myspace.com/zegrae; Burningangel.com; Ryan Ouellette; Tom Broadbent

CONTRIBUTORS
Photos: Ashley/Savageskin.co.uk; Shannon Larratt/Bmezine.com; Tom Broadbent; Zen Inoya; Doralba Picerno; Steve Haworth; Alamy; Rex Features; Samppa Von Cyborg/Madmaxtattoo.com/Voncyborg.com; PA Photos;Quentin/Kalima.co.uk; Puncturedbodypiercing.co.uk; Discovery; Topfoto; Ryan Ouellette; Ron Garza; John Durante/Laughingbuddhatattoo.com; Joe Plimmer; Byblair.com; Garth Staunton; David Friedman/Getty Images; Jamessooy.com; Corbis; Kevin Warwick; James Stafford; Burningangel.com; Thedungeoninc.com; Zegrae/Zegrae.co.uk/Myspace.com/zegrae; Fakir.org
Words: Amy Salter (Modding And Big Ears/Tatt Facts); Doralba Picerno
Special thanks: Dave Tusk; Darren Brooke; Dave Kinnard

Origination and retouching by Mullis Morgan Imaging

We occasionally use material we believe has been placed in the public domain. Sometimes it is not possible to identify and contact the copyright holder. If you claim ownership of something we have published, we will be pleased to make a proper acknowledgement. All letters received are assumed to be for publication unless otherwise stated. *Bizarre* cannot be held responsible for unsolicited contributions.

ISBN: 9780857680808

Published by Titan Books
A division of Titan Publishing Group Ltd.
144 Southwark St.
London
SE1 0UP

First Titan edition: May 2011
10 9 8 7 6 5 4 3 2 1

Did you enjoy this book? We love to hear from our readers. Please e-mail us at: **readerfeedback@titanemail.com** or write to Reader Feedback at the above address.
To receive advance information, news, competitions, and exclusive offers online, please sign up for the Titan newsletter on our website: **www.titanbooks.com**

A CIP catalogue record for this title is available from the British Library. Printed in China.

Complex and elegantly inked tattoos have been popular in Japan for centuries

A BRIEF HISTORY OF
BODY Art

TATTOOS, PIERCINGS AND SCARIFICATION AREN'T MODERN CREATIONS. IN REALITY, BODY ART IS AS OLD AS THE HISTORY OF MAN

WORDS **JAMES DOORNE**

Humans are the only species on the planet that choose to systematically change and manipulate their appearance. Whether it's through temporary changes such as painted nails, lipstick or a fashionable hairstyle, or more extreme body modifications such as piercings, tattoos and implants, no human society has ever left its appearance to genetic inheritance alone. From supposedly primitive cultures to the most advanced, human appearance has always been created by a combination of cultural influences, as well as biological factors.

With the recent increase in the popularity of body modifications, you'd be forgiven for thinking tattoos, piercings and so on are modern creations. However, the reality is quite different. What's really happening is a cycle of discovery and rediscovery that's been going on for thousands of years, as one generation or culture discovers the body modifications of another and claims them as their own.

ANTIQUE INK

Tattoos are the best-known body modification to ever hit mainstream culture. Some estimates claim that one in six North Americans has at least one tattoo, and it's likely that you know at least half a dozen people with inked skin yourself. But the practice actually pre-dates the Bible; in Japan, for example, tattooing for both spiritual and decorative reasons is thought to have existed for at least 10,000 years. In 1991, a well-preserved natural mummy was discovered in the Ötztal Alps, near the Hauslabjoch pass on the border between Austria and Italy. 'Ötzi The Iceman', as he became known, was calculated to have died in 3300 BC, and yet had a total of 57 tattoos, including a cross on the inside of his left knee, six 15cm-long straight lines on his back, and many other tattoos on his legs and ankles. Other tattooed mummies have also been found with designs featuring animals and monsters that covered large areas of their bodies.

And it's not only established body modifications such as tattoos and piercings that have been practised for centuries; many body mods that are currently coming into fashion – notably scarification and branding – have their historical roots in tribal communities.

Occasionally these body modifications were simply a pragmatic act – a way for members of one tribe to differentiate themselves from members of another – but sometimes there was deep cultural significance attached. Body modification was often the means by which tribal customs and rituals were enacted during symbolic ceremonies, with rites of passage such as coming of age often including a body modification to represent a new rank or enhanced status. As a result, many tribes have separate forms of body modification for men, women and children to denote life stages. In some African tribal cultures that practise scarification, a child's first cut may be given shortly after birth, with more added later to denote maturity. Scarification has also been used to indicate status and responsibility; in some tribal cultures, when a woman was willing to be scarified, she was considered mature enough to be a child bearer.

Like in modern scarification (see page 60), many African tribes agitated wounds to make scars more prominent, with cuts covered in charcoal or scrubbed with abrasive substances. And while today's most innovative body artists are fusing tattoos and scarification, tribal cultures have been inserting dyes into fresh wounds for centuries to create pigmented scars, resulting in marks that look like modern tattoos, albeit without the fine detail possible with contemporary inking machines. ➡

'ÖTZI THE ICEMAN' A MUMMY DATING BACK TO 3300 BC, HAS 57 TATTOOS

'The Horseman', a 2,000-year-old mummy from the Chinese and Mongolian borders, has a deer tattooed on his shoulder

A doctor marks the face of a young girl with tribal symbols in Ibadan, Nigeria, in March this year

In tribal cultures, body art was a sign of maturity and status

Surma women of
western Ethiopia
still wear lip plates

Samoan tattoos have also been applied by hand for the last 2,000 years; an apprentice artist will practise carving designs into trees before being considered ready to work on humans using the traditional tattooing tool of a sharpened boar's tooth fastened to a piece of shell with a wooden handle, with burned nuts used to create the dye.

New Zealand Maoris used a similar process to create coloured scars called *ta moko* that represented their tribal status. Traditionally the design was chiselled into the skin with an albatross bone, and pigment from vegetation was used to make colours that emphasised the design. It was applied to both men and women; on the faces and buttocks of men, and the chins, lips and shoulders of women. Higher-ranking tribe members would have *ta moko* on their face, while women sometimes put marks on their shoulder to indicate someone close to them had died.

As well as showing the individual's position within the tribe, the scarring was historical; designs on the left side of the face related to the father's history, and the right the mother's. Some Maori chiefs even used the pattern of their *ta moko* as a signature when signing land treaties with settlers.

LOST PRACTICES

Inevitably, not all body modifications have survived the march of modernity. In China from the 10th to early 20th century, girls born into aristocratic families and those destined to become courtesans

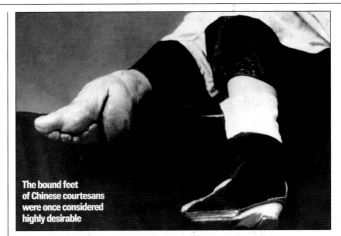

The bound feet of Chinese courtesans were once considered highly desirable

TRIBES ACROSS THE WORLD SHAPED CHILDREN'S SKULLS BY BINDING THEM

were subjected to foot binding, and the Chinook tribes of North America shaped the skulls of their infants into a point by binding them between wooden boards. Similarly, the African Mangbetu tribe favoured an elongated skull and bound the heads of babies in tight cloth, resulting in distorted growth.

Anyone who grew up reading *National Geographic* will know that lip plates are popular with the women of Chad, sometimes stretching the bottom lip so much that they make speech almost impossible. It's thought this body modification was originally designed to deter slave traders from stealing women from specific tribes, but ended up becoming a mark of status and beauty.

Women of the Surma tribe in Ethiopia still wear lip plates, and the larger the plate the more cattle are required in payment to win the woman as a bride. But while some Surma women still wear lip plates in an attempt to preserve ancient tribal traditions, many now refuse to adopt the practice due to the infiltration of Western influences.

And ancient cultures didn't just practise binding, inking and cutting. Far from being a modern invention, piercing – the most widespread of all body modifications – has been documented in numerous tribal societies across the globe.

Indigenous people in America, Africa and Asia adorned their bodies with a variety of piercings, ➡

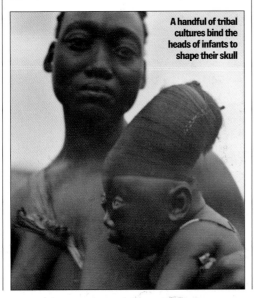

A handful of tribal cultures bind the heads of infants to shape their skull

often unique to a particular tribe or culture. And while the cultural significance they once held has been lost, it's interesting how the placement of piercings favoured by 21st-century body artists are identical to those adopted by tribal societies.

The book of Exodus 21:5-6 (dated 1440 BC) describes how Hebrew servants, in order to pledge allegiance to their master, would have their ear pierced with an awl – a pointed instrument for making small holes in leather or wood – to identify the recipient with a particular family.

And while navel piercing has become the body mod of choice for teenage girls, the practice was popular with Ancient Egyptian royalty, and such an upper-class pursuit that it was denied to commoners.

Male and female genital piercings were also popular in tribal cultures and were employed to enhance or inhibit sexual activity. For example, the frenulum piercing – located on the underside of the shaft of the penis – while often used to enhance an erection, can also be adapted to prevent intercourse

TRIBAL CULTURES USED GENITAL PIERCINGS TO ENHANCE SEXUALITY

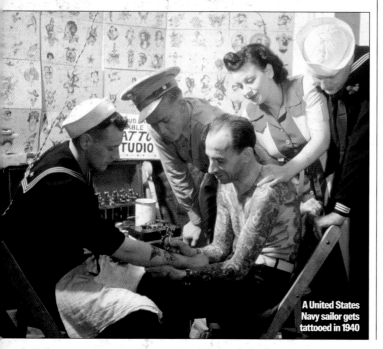

A United States Navy sailor gets tattooed in 1940

or masturbation. One of the oldest recorded genital piercings, the apadravya – a piercing through the head of the penis, passing vertically from top to bottom – was even mentioned in the *Kama Sutra*.

MODERN BODY ART

A popular misconception, even amongst those who know their history, is that body modification has only wormed its way into Western culture in the last few decades. Of course, that couldn't be further from the truth.

The grand tradition of tattooed sailors began with Captain Cook's voyages to the South Pacific in the late 18th century, when his crew copied the tattoos of communities they encountered on their travels and, over time, developed their own designs.

Cook's diary is also thought to record the first use of the word 'tattoo'. He wrote: "Both sexes paint their bodies, *tattow* as it is called in their language. This is done by inlaying the colour of black under their skins, in such a manner as to be indelible."

And although it's often portrayed as a period of bigotry and moral repression, Victorian England had a thriving piercing subculture. In fact, one of the most popular male genital piercings, the Prince Albert, gets its name from Queen Victoria's husband, who was alleged to have been one of the early adopters of the practice. (As was Benito Mussolini who, it's been claimed, had a penis piercing he used to tug on when he was nervous.)

The Prince Albert – or PA as it's commonly known – involves the insertion of a ring through the urethra and glans, from the outside of the frenulum. Stories suggest that Prince Albert had one inserted prior to his marriage to his then-cousin as a means of retracting the foreskin, lest Victoria be bothered by unseemly odours. Others offer a different explanation; male fashion in the 19th century involved wearing indecently tight trousers that left the genitals as an obvious bulge, with the potential to offend ladies. However, those with a PA could use it to hook their penis to one side of their trousers and spare a woman's blushes. And some writers claim the whole story was fabricated by body mod pioneer Doug Malloy in order to legitimise piercing.

Around the same time, women were also piercing their nipples, and the 'bosom ring' became a stylish accessory for women of high society. Parisian craftsmen sold beautiful and expensive jewellery that could be inserted through the nipple, and some women even wore a chain connecting the bosom rings through each nipple. ➡

A Dani tribesman in the central highlands of western New Guinea wearing traditional ceremonial garb, including an imposing septum piercing

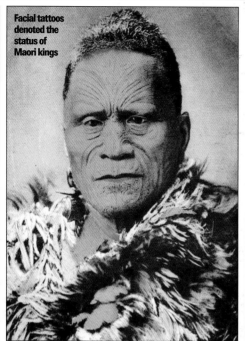

Facial tattoos denoted the status of Maori kings

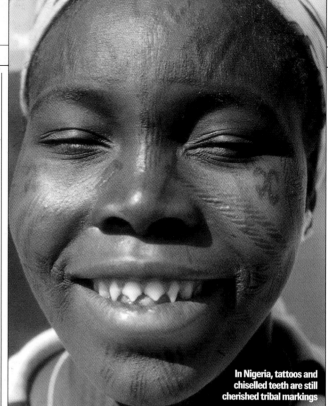

In Nigeria, tattoos and chiselled teeth are still cherished tribal markings

One side effect of wearing a bosom ring was that the nipples would enlarge and become painful. However, fashionable women considered that a risk worth taking; one socialite writing in *Vogue* in the 1890s noted that the rubbing against tight corsetry caused a state of "constant excitation and titillation".

The fact that piercing was once the preserve of the upper classes might seem odd, but it was the same with tattoos before piercing became chic. At the turn of the 19th century it was estimated that 20 per cent of the British gentry were tattooed, and many English kings and queens are said to have been inked; King Harold II's corpse was identified on the battlefield at Hastings in 1066 by the words 'England' and 'Edith' (the name of his mistress) tattooed on his chest. King George V had the Cross of Jerusalem inked on his arm, and even Queen Victoria is rumoured to have had an "intimately placed" tattoo.

All this goes to show how cultural reactions to body modifications have changed over time, and poses intriguing questions about how opinions will evolve in the future.

Thanks to the ascendency of the internet, more people know about body modifications than ever before through sites such as Shannon Larratt's Bmezine.com. The web has also created a marked

TODAY, PEOPLE ARE FUSING FLESH, METAL, SILICON, INK AND TEFLON

increase in the accessibility and range of body modifications offered by experienced practitioners around the world. Steve Haworth (see page 42) is frequently rewriting the rulebook on implant technology, and Ryan Ouellette (page 60) and Blair (page 90) are adapting and refining cutting and branding practices respectively.

Today, extreme body modification is a subculture that regularly seeps into the mainstream, with more people becoming hybrid bodies each day by fusing flesh, blood, metal, ink, silicon, Teflon and other substances.

And for the first time in history, this generation can contemplate the fusion of functional implants with aesthetic ones; cochlear implants for the hearing impaired and pacemakers to regulate heart rate are common procedures, as are lens implants behind the cornea.

As a species, we're no longer approaching an age of posthumanism; we're already there. And who knows where we'll be in 50 years' time. **B**

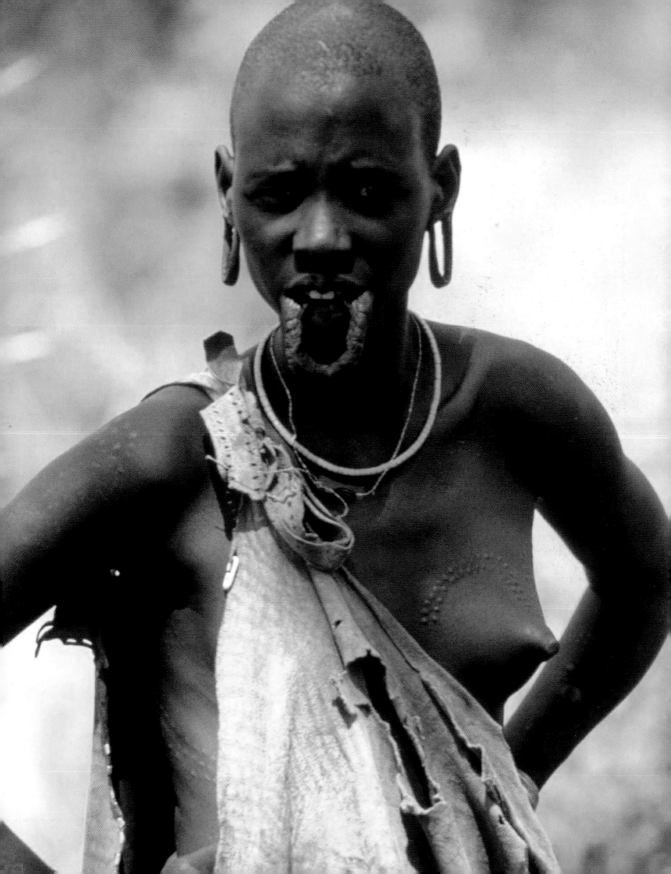

SKULLS

IF YOU LOVE YOUR BONE IDOLS ENOUGH, GET THEM INKED ONTO YOUR SKIN...

BEX

Who did it? Kev Denny at Underground Tattoo Studio, Walsall, UK.

What is it?
It's a collaboration of a few favourites.

Why did you choose it? It's different.

How do you feel about it now?
I love my tattoos and have never regretted any of them.

WESLEY CANNON

Who did it? Julie Maines at Gary's Skin Graffix, Goldsboro, USA.

Why did you choose it? I'm a huge *Nightmare Before Christmas* fan.

How do you feel about it now? I absolutely love it! It's one of my newest tattoos. I've always loved the movie and Tim Burton's work.

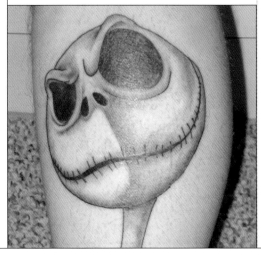

JESSICA WILLIAMS
Who did it?
Keith Hieserich, Minneapolis, USA.
Why did you choose it? There's no silly 'it means something' like they say in *Miami Ink*. I get my tattoos because they look cool.
How do you feel about it now?
I love all my tattoos.

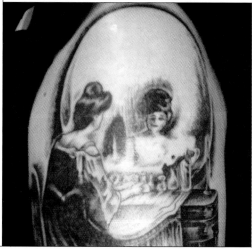

JOHN
Who did it? Nicola Bagnall at Celtic Art Tattoo, Chesterfield, UK.
What is it? It was designed by Paul Booth of Last Rites in New York.
Why did you choose it? I was going to design one myself, but when I saw this I knew it was going to be a good place to start my tattoo collection.

IAN 'SNAKEBITE' BROWN
Who did it?
Kev at Draconian Tattoo, Aberdeen, UK.
Why did you choose it?
I just like skulls and tattoos. I thought the design would fit nicely on my front, with the odd body modification as well.
How do you feel about it now? Fuckin' love it! ➡

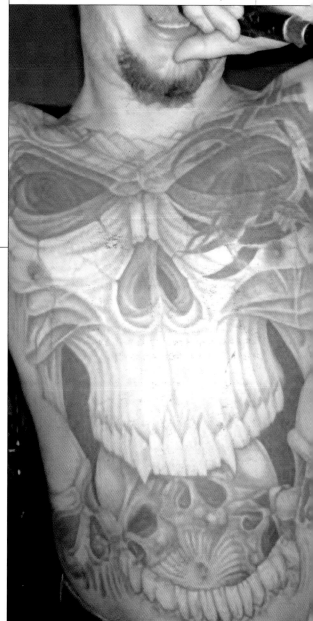

DAN WHILEMAN

Who did it?
Shaun in Stavely, Chesterfield, UK.
What is it?
A Mexican death skull butterfly.

How do you feel about it now?
It took around three hours to do the tattoo, but it was
well worth the effort.

PAUL MCCONNELL

Who did it? Jesse Brown designed it.
It was done in a shop in Camden Town,
London, UK – I can't remember the name.
How do you feel about it now? Usually
when I show it to people they can't believe it's real.
But I have a skull and crossbones wearing a sombrero,
flanked by two tequila bottles, on my arm. Brilliant!

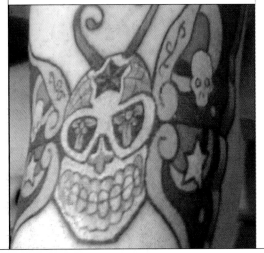

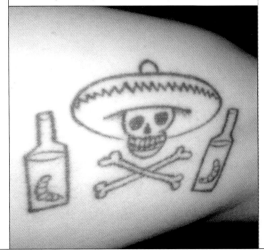

MAX ANDREWS

Who did it?
Slug at Tattoo World, Trowbridge, UK.
What is it? A skull with flint axes.
Why did you choose it?
I just fancied a tattoo, and skulls are cool.
How do you feel about it now?
I still like it!

TERI TOXIC

Who did it? Paul Rogers at From Beyond
Tattoo Studio, Glasgow, UK.
What is it?
It's based on the song 'Psychobitches
Outta Hell' by the Horrorpops.
Why did you choose it? My boyfriend got me it for my
birthday because I'm a psycho bitch from hell!

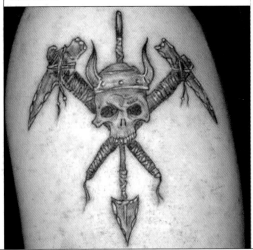

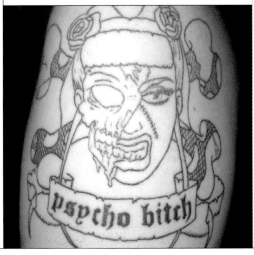

LEIGH SHELTON

Who did it? Rabbit at Grin'n'Wear It Tattoo Studio, Lakenheath, UK.
Why did you choose it? I'm just drawn to skulls and skeletons.
How do you feel about it now? I've had it for 12 years. People often ask me what's on my head – they must think I fell foul of a pigeon or something.

ANTONY HALL

Who did it? Paul at Eternal Ink, Sheffield, UK.
What is it? A skull and crossbones.
Why did you choose it? It's supposed to mean dangerous and toxic.
How do you feel about it now? I love all my tattoos and want more. I just can't afford any at the moment.

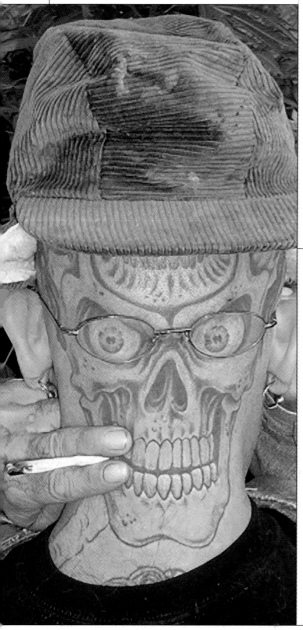

AILSA BANNERMAN

Who did it? Nick Reid at Diamond Jacks, Soho, London, UK.
What is it? A skull with stylised waves.
Why did you choose it? I love pirates and the sea. I already had a seahorse tattoo, so I wanted it to match. I look fairly straight, so it surprises people that I've got a skull on my back! ⓑ

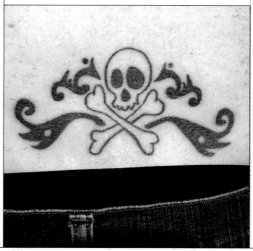

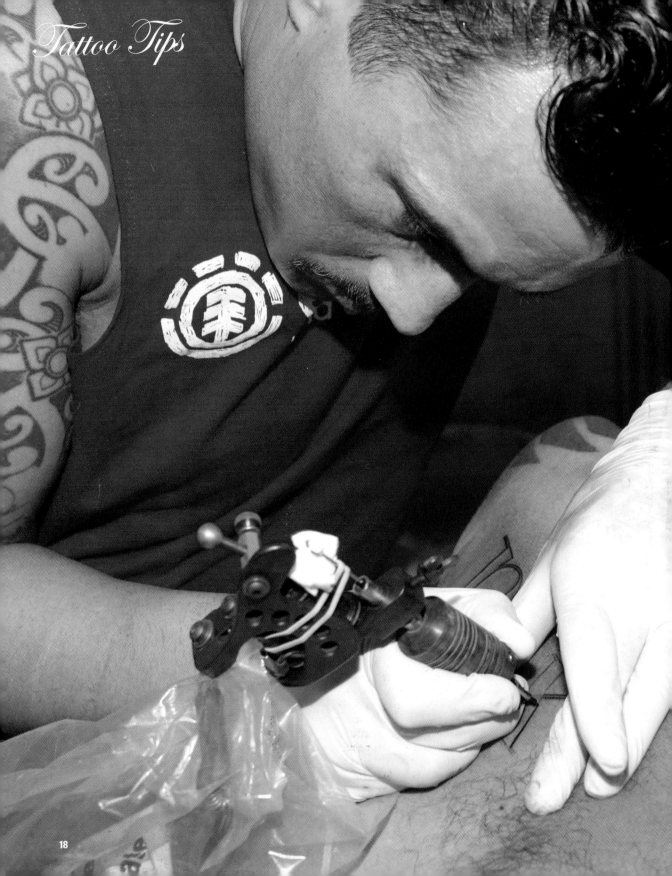

Getting INKED

WHETHER YOU'RE CONSIDERING YOUR FIRST TATTOO OR GETTING MORE WORK, *BIZARRE*'S FAVOURITE INK EXPERT, DAVE TUSK, HAS SOME WORDS OF ADVICE YOU'D BE CRAZY TO IGNORE

WORDS **JAMES DOORNE** PHOTOS **TOM BROADBENT**

Getting your first tattoo is a huge step, and there are many questions that need to be answered: Am I ready for it? How can I find the right tattooist? What design should I go for? How should I prepare?

Dave Tusk sees it every day. As well as being a circus freakshow performer in The Fire-Tusk Pain Proof Circus, and bass player in zombie swing band The Flaming Doo Dits, he's also one of the best tattooists in the UK and a favourite of *Bizarre*.

Here's Dave's guide of things to consider before going under the needle. And you might be surprised by how much you don't know…

Dave's studio, Tusk Tattoo, is at 1 Stukeley Street, London WC2B 5LB. Also see Tusktattoo.com and Myspace.com/tusktattoo

THINK ABOUT YOUR TATTOO

If you've seen a beautiful piece of art or a tattoo that's inspired you, then you're probably ready to get some work done. But if you're in a pub and you suddenly decide you want a cobweb on your face, then you should wait and think about it more.

One thing that happens a lot is that people give tattooists too little information. They're like, "Do what you want, you know best…" and that's a risky card to play. Giving artists room to express themselves can often work well, but at the same time it can leave you open – at your own cost – to getting something you don't like.

Artists want as much information as possible so that they can give you advice on the execution of your tattoo, so come up with something definite for them to work with. And be creative. Most tattooists will turn down a girlfriend or boyfriend's name because we hate having to cover that shit up a month later. And unless it's part of some kind of sex game, if you've got 'Property of Olaf' tattooed across the front of your bearded clam, what does that say about you? Have you got a bad memory or something? It's a bad look. I'd rather tattoo a girlfriend's phone number onto a client than a partner's name. It's a recipe for disaster. One of my first tattoos was a girl's name, and I had to cover it up like everybody else. Don't put yourself through it. If you're with someone that you like, get something that reminds you of them. Then, if the relationship ends, you'll still have a nice tattoo, not some misshapen cover-up.

DECIDE WHERE YOUR TATTOO SHOULD BE

Don't just think about the design – also consider where it's going to appear. If you fancy a tattoo in an area that can be easily covered up, like the groin area or your hip, then I think it's fair enough for a tattooist to proceed. However, if you don't have any tattoos and you want a design in a visible place like your neck, hands or, particularly for ladies, below the elbow, then you should give it more thought.

If you're heavily tattooed, mature, employed, and your career is such that having a tattoo won't make much of a difference, then go for it. But if you're 18, never had a job, and you come in wanting a bad boy badge on your neck as your first tattoo, most artists will refuse you. And we *will* ask questions before starting work.

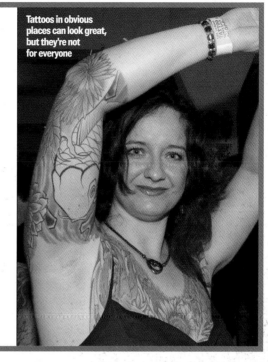

Tattoos in obvious places can look great, but they're not for everyone

TATT FACT

In ancient times during periods of war, warriors were tattooed with secret symbols to silently sneak messages across enemy lines

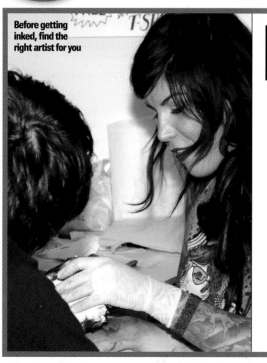

Before getting inked, find the right artist for you

FIND THE RIGHT TATTOO ARTIST

Once you're satisfied with your tattoo concept, talk to as many tattooists as possible to find someone you feel comfortable with. If you go to a studio and they just say, "Yeah, yeah, yeah…" and the shop seems cliquey and they look down their nose at you because you haven't got loads of tattoos, then walk away. Feeling positive about getting a tattoo makes it more likely that you'll enjoy the experience and get a better piece of work.

Also, it's a huge barrier if no one in the shop speaks the same language as you. It can take a lot of discussion with a tattooist to agree on what you want, and how you want the work to be done. If it's something simple like a five-pointed star, you could probably get that tattoo using sign language. But it's hard to describe effects and so on if you're not an artist yourself, so make sure you can communicate with your tattooist. ➡

4 CHECK OUT THE TATTOO STUDIO

Once you decide on a place to get your tattoo, make sure the shop has a licence and phone up your local health and safety authority to ask if they've had any complaints, convictions or warnings against them. Even if they've been in trouble in the past, it doesn't necessarily mean the council will close them down, and you'll have no way of knowing unless you check. If you don't, you could be sharing blood with people that you don't even know.

Find a reputable shop before getting inked

5 ALWAYS ASK TO SEE A TATTOOIST'S WORK FIRST

Never use a studio where there are no photos of the artist's work on display, just loads of random tattoo books and pictures on the walls. You need to see an artist's work before getting a tattoo done. And check the pictures in the tattooist's photo album aren't just digital pictures that have been manipulated; make sure the skin in the photos looks like real skin. Personally, I'm a bit old school and use traditional 35mm film to take photos of my tattoos. You can't argue with a high-quality, well-taken, well-lit photograph.

Do the shop's pictures look real? If so, go for it

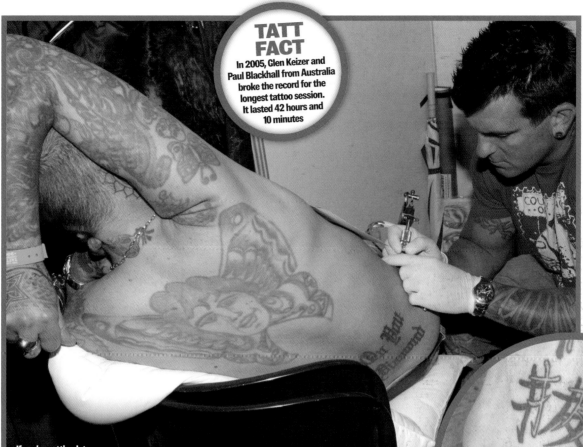

TATT FACT
In 2005, Glen Keizer and Paul Blackhall from Australia broke the record for the longest tattoo session. It lasted 42 hours and 10 minutes

If you're getting lots of work, make sure to book an early appointment

6 MAKING YOUR BOOKING

Your first tattoo will be a shock to your system, so even if you're confident and the work is being done in a comfortable place, don't book yourself in for longer than three hours. Psychologically, if you book yourself in for longer then you'll soon be thinking, "Oh my God! What the fuck am I doing?" especially during the first few hours when it really hurts. And if it's your first tattoo and you want a big piece of work done in a painful place, don't be surprised if the artist won't take you on, as it's difficult to work on someone who isn't properly prepared.

While pain is subjective, there are some bad places to get tattooed: ribs, fingers, toes, kneecaps, behind your knees and the front of your throat. The face hurts, especially near the lips, and feet really hurt too. The side of my head didn't hurt much when I had it done, but I have a feeling that down the middle would be really painful. Extremities and areas with thin skin *will* hurt. ➡

7 BOOK AN EARLY APPOINTMENT

Physiologically, men become charged with testosterone while they're asleep, so it's a good idea to book an early appointment. Start a tattoo at noon rather than 9pm and you'll have a lot more testosterone and adrenaline to help with the pain. It also helps to get a good night's rest before having a tattoo.

It's similar for girls, but obviously they don't have testosterone and their hormone release is more even throughout the day. But for women it's still worth getting work done in the morning as you'll be fresher.

CONSIDER THE COST

In the UK, most tattooists charge between £50 and £100 an hour, and the average people spend on a tattoo is about £220, which will buy you around three hours. If you want a quote, then take an image of the design you want to a few different tattooists and ask how long it would take, and how much it would cost. Some shops price by the piece. In this situation, make sure your tattooist agrees on a flat rate upfront.

Talk to a few tattoo artists before getting your work done

Your tattoo is going to hurt, so prepare yourself mentally first

9 BE PREPARED FOR PAIN

If you go for a tattoo expecting to feel nothing, then you'll have a terrible time. But if you realise it's going to hurt and that the pain will last for a while, you'll stand up to it better. From my perspective, it's always best if the person I'm tattooing is aware that the work will be painful.

We get asked a lot about painkillers. If you take ibuprofen, which has an anti-inflammatory, it might not help with the pain of the tattooing itself, but it will make you less likely to swell.

Do not take aspirin! Aspirin will thin your blood and make you bleed more. You'll stream with blood. One aspirin will last a weekend, so avoid aspirin for three days before getting a tattoo.

Regulating your breathing can help you deal with the pain. If you meditate or do yoga, try some breathing exercises while getting the tattoo done. And if you've got a sore spot on your body, try not to tense up and hold your breath; instead, try to exhale for as long as you can.

You shouldn't have a stiff drink or spliff to calm your nerves; reputable artists won't tattoo you if you've been taking drugs or drinking. It's just good practice, as well as the conditions of our licence. Also, if you're nervous, it might heighten those feelings of nervousness and actually work against you.

And if you tattoo someone who's been drinking – or even drunk a lot the night before and they still have alcohol in their system – they'll bleed a lot more and the tattoo will take even longer to complete. ➡

TATT FACT

In the early days of tattooing, dust from building bricks was used to make red colouring, and soot was used for black and blue

HYGIENE IS VITAL

Hygiene is a complex subject, so it's hard to give broad advice. However, make sure your tattooist prepares all the equipment properly. In our shop we use an impervious, disposable surface and single-use, pre-sterilised needles that are thrown away after each tattoo. When watching a tattooist set up, check that they're using new equipment and leave nothing on the side when they're finished.

Ask as many questions as you like. Tattooists are there to reassure you and make you feel comfortable. My clients often ask to watch the packet of needles being opened, and we're always happy to show them. If the tattooist is cagey, then walk away. Hygiene is vital because during a tattoo the access to your bloodstream is opened, and if other people's blood gets into your body you could potentially catch any number of diseases.

Gloves are good, but they're not a complete barrier. In our shop all our tattooists wash their hands before putting the gloves on, and there will be many changes of gloves during the procedure. If you've touched any bodily fluid, even when wearing gloves, then you shouldn't touch anything else that should be kept clean. A lazy tattooist might touch lots of things with the gloves on and that's not good practice.

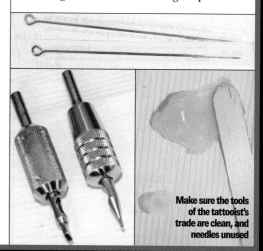

Make sure the tools of the tattooist's trade are clean, and needles unused

AFTERCARE

You can put a layer of ointment on a fresh tattoo – maybe petroleum jelly, Bepanthen or Bacitracin – then cover it with clingfilm. That stops oxygen from reaching your skin and allows it to weep more lymph, for longer, and prevents scabbing.

When you take the clingfilm off, give your tattoo a long hot wash with some mild anti-bacterial soap and massage the skin in a hot shower. This will massage out a lot more lymph than if you just put a dry dressing on immediately after getting a tattoo. You should then finish with a cold rinse to close the pores; that means the scab on your tattoo will be thinner and likely to flake off, rather than scab thickly, crack and break the design. The shading will be smoother if it heals with less trauma.

Also, while you can wash your tattoo rapidly, you mustn't soak it in the bath. If you've got a fine scab on your skin and you soak it, the scab will absorb water and become fluffy. If this happens you can brush the scab off with a towel but you might remove some of the pigment below.

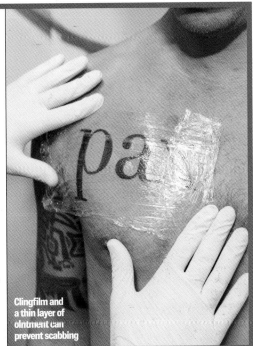

Clingfilm and a thin layer of ointment can prevent scabbing

IF YOU NEED A COVER-UP...

If someone needs a cover-up, they'll typically choose a design that's got a black section in it that can be used to block out a name they want to forget. But while they might be happy the day the name is covered, all they'll have done is replace something shit with something else shit, and two weeks later they'll be thinking, "I hate that black blob, I should have got something better."

People are often surprised with what you can do with a composite design to cover something up; sometimes it can literally look like the original tattoo was never there.

Before getting a cover-up, think carefully about what you'd like to see on that part of your body and talk to your tattoo artist about it. It may work, it may not. But don't start thinking that you have to completely cover a bad tattoo – there are many ways to fix mistakes.

For some people, cover-ups are a stylish way to enhance existing tattoos

Above: Dave's stomach features a dazzling range of tattoos

ONE FINAL WORD OF ADVICE FOR TATTOO VIRGINS

A tattoo isn't a mystical amulet, a passport to coolness or a bad boy badge. It should be something that, when you look at it, makes you feel good. And this is vital as you're going to be looking at it for a long time. That should be number one on your list of things to consider before getting work done… and number two on your list, and number three.

It's a common scenario that someone goes into a shop and says, "I want a tattoo… and I want it to be this big… and I want it to be original… and I want my mother/brother/boyfriend's dog to design it… and I want it to mean something… and I want it without a black outline… and I want it on the sole of my foot." Too. Many. Things.

Originality? Nothing's original. You want your friend to design it and the tattoo to be meaningful?

Forget it. It *will* be meaningful because it's your first tattoo, but it's impossible for it to be all things to all people. Forget all that bollocks. You'll just end up getting it covered up later.

Whatever age you are, think what you were like five, 10 or 20 years ago. Think what you were into then, and think of all the changes that you've got ahead of you.

Focus on the important things, not transient things that are in your head that week. You wouldn't go into a sandwich shop and order tuna sandwiches every day for the next 10 years because you're into tuna this week. The most important thing is that, when you look at your tattoo, it always makes you feel good. Think about the future before going under the needle. ⑬

MODIFY ME

IF YOU'RE GOING A BIT FURTHER AND WANT A HARDCORE BODY MODIFICATION, WHO BETTER TO GIVE YOU GUIDANCE THAN A MAN WITH A METAL MOHAWK IMPLANTED IN HIS HEAD?

WORDS **DAVID MCCOMB**　PHOTOS **ZEN INOYA**

amppa Von Cyborg – profiled on page 80 – is one of the reigning kings of body modification, responsible for creating some of the most famous procedures in the world today, including Flesh Staples and MadMax Bars. We asked Samppa what advice he'd give anyone considering a body modification, and here's his five-point plan.

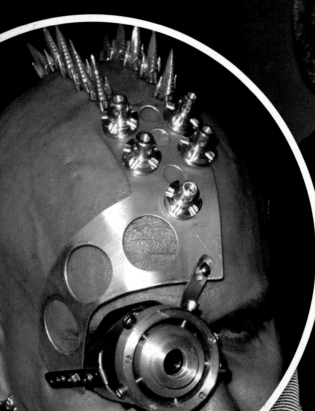

CONSIDER YOUR CAREER

You've got to think about your career. There are so many kids getting body modifications when they're at college, but they don't realise they're not part of the real world yet. It doesn't matter what qualifications you have – you won't get a job, because no one wants to hire someone who has spikes in their head. Only get permanent stuff when you know what path your life is taking.

THINK ABOUT IT

Body modification is a lifetime process. I've seen 20-year-old kids getting full-body tattoos, along with implants, piercings and whatever – but after that, they don't have anything left to do.

Think long and hard before getting any body modifications. Some people rush into getting work done, when in reality you should think about it for a few years because you might change your mind or get better ideas about what work you'd like to get done.

BODY MODS ARE EVOLVING

Body modification evolves fast. And while you might be able to get something that's cool now, in a year you'll be able to get something even fucking cooler. Every day people are coming up with new ideas. And anyway, you might want something different when you're 40 than when you're 20, so you shouldn't get too much done in a single year.

THERE ARE RISKS Because

body modification is an evolving field, much of the work we do is experimental and we still need to wait 20 years before we really know if these procedures are safe. You might get bad complications, and it's impossible to tell how some people's bodies will react.

My metal Mohawk is fine now, but there are no guarantees I'll be able to keep it. And if you remove a metal Mohawk it leaves nasty scars. Having a body modification is also a massive risk.

BE CAREFUL WHO DOES THE WORK

There are people who've only been in the business for a year, and they're already using scalpels and needles to give people modifications. But a scalpel can kill you. These people aren't just taking risks with their own bodies – they're taking serious risks with other people's lives. Above all else, make sure your body modifier has enough experience and training. ⓑ

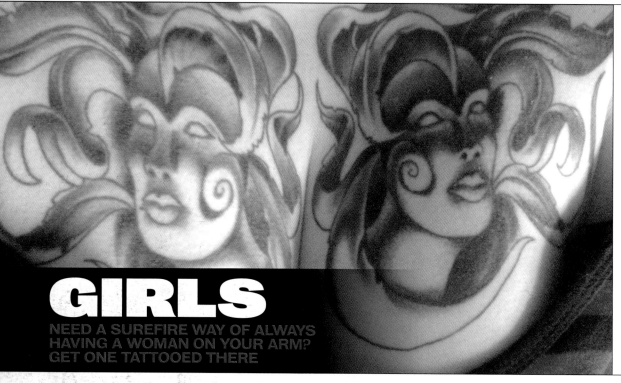

GIRLS

NEED A SUREFIRE WAY OF ALWAYS
HAVING A WOMAN ON YOUR ARM?
GET ONE TATTOOED THERE

ALLY GARDINER

Who did it?
Andy at Andy Barber's, Raynes Park, UK.
What is it? It's from a painting by Frida
Kahlo called *The Broken Column*.
How do you feel about it now? I'm shy, so it gives me
the perfect excuse to ramble on about art. I can't count
the number of times men have shouted, "Nice tits, love!"

TINA-NICOLE

Who did it? Rob Doubtfire at Rob's
Tattoo Studio, Bradford, UK.
What is it? A piece of Trevor Brown
art that I first saw in *Bizarre*.
How do you feel about it now? I love the design, and
I've won competitions with this tattoo. Cheers *Bizarre*
for introducing me to the wonders of Trevor Brown.

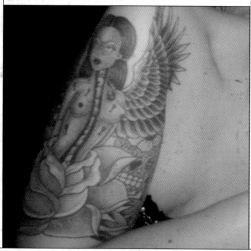

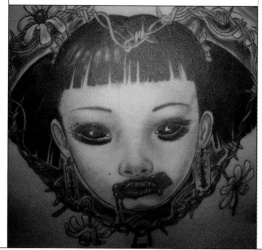

PFIL

Who did it?
Phil at Skintech, Bournemouth, UK.
What is it? Bondage fairies.
Why did you choose it?
Because I'm Pfil the bondage fairy, haha!
How do you feel about it now?
I love all my tattoos. I wouldn't be without them.

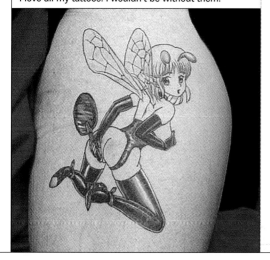

MACHINEFLESH AKA STU

Who did it?
Myth at Indigo Tattoo, Northwich, UK.
What is it?
Bloodied women and horror portraits.
Why did you choose it? This is my thing.
How do you feel about it now? Put it this way, I don't think I'll be getting them lasered or covered. ➡

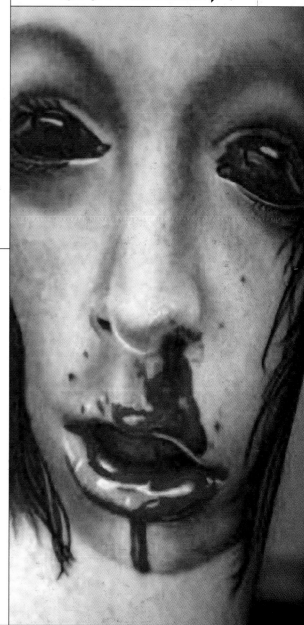

MARTIN HOLGERSSON

Who did it? Nikke Wiman at Black Magic Tattoo, Karlshamn, Sweden.
What is it?
A naked bondage chick.
Why did you choose it? I found the design discarded at the shop. Some guy had asked Nikke to design it, but then chickened out – so I snagged it.

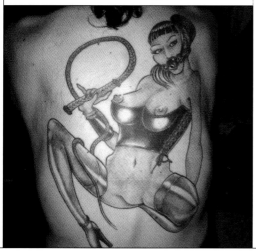

THISTLE HARLEQUIN

Who did it? Pika at Inkfatuations Tattoo, Port Hueneme, USA.

What is it? Divine in her dress from *Female Trouble*.

Why did you choose it? I'm a huge fan of Divine, she's my idol. The tattoo isn't complete yet – how could a Divine tattoo be complete without dog faeces?

DEAN FOREMAN

Who did it? My girlfriend Helen Soulsby at Xtreme Ink, Hartlepool, UK.

What is it? Pin-up girls. The bunny girl on my calf took six hours.

How do you feel about it now? Helen's famous for her sexy pin-up girls, and I plan to have a leg completely filled with them.

GARY SPALDING

Who did it? Ruben Youngblood at Rude Boy Studio, Norwich, UK.

What is it? A bloodthirsty zombie bitch.

Why did you choose it? Because I thought she was sexy and evil.

How do you feel about it now? I love it. It's the best tattoo I've ever had.

JEFFREY LEE ADAMS

Who did it? Scot Ives at Magnum Tattoos, Wyoming, USA.

Why did you choose it? The Masochistic Monarch (a superhero) is a supporting character in my first screenplay, *Eve The Elf*. As I'm a fan of the deliberate infliction of pain, I wanted scenes of BDSM immortalised on my body.

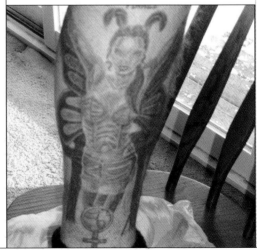

PAUL DOBSON

Who did it? Sean Milnes at The Adventure Tattoo Studios 2, Keighley, UK.
What is it? An angel sitting on a rock.
Why did you choose it?
It was out of a design book in Sean's shop.
How do you feel about it now?
I'm very happy – it's one of my best tattoos.

KATIE

Who did it? Jeff in Wellington, Telford, UK.
What is it? A Manga girl.
Why did you choose it?
I'd had three Manga pictures that I loved combined into one striking image.
How do you feel about it now? I love it, and it's given me the tattoo bug. Now I've got more work planned.

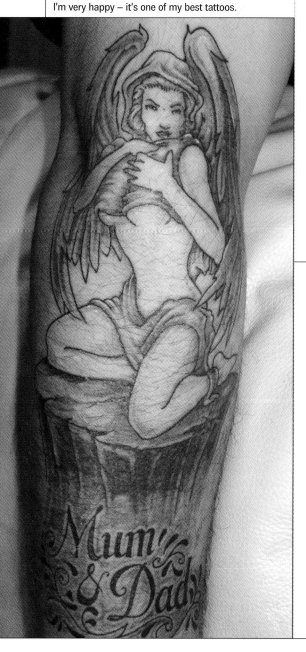

SAM

Who did it?
Mark at Sacred Heart, New Zealand.
What is it?
A Residents go-go girl.
How do you feel about it now?
She's always there when my bird's away, and I've even chucked out my porn. Ⓑ

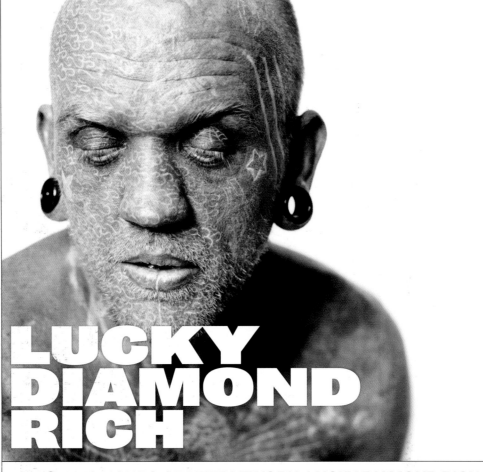

LUCKY DIAMOND RICH

AFTER 1,150 HOURS OF NEEDLEWORK, LUCKY DIAMOND RICH IS OFFICIALLY THE WORLD'S MOST TATTOOED MAN, WITH 220 PER CENT BODY COVERAGE IN SEVEN LAYERS OF INK

WORDS AND PHOTOS **DORALBA PICERNO**

*I*f you've ever wandered around London's Covent Garden or visited a tattoo convention, chances are you've already seen Lucky Diamond Rich. After all, he's the kind of person who stands out in a crowd. With skin as black as night thanks to as many as seven layers of ink, Lucky is officially the most tattooed man on the planet.

Born Gregory Paul McLaren in New Zealand in 1971, Lucky got his first tattoo – a small juggling club – in London at the age of 17, on the same night he lost his virginity to a King's Cross hooker. By the time he reached his mid-20s, more of Lucky's body was

tattooed than wasn't. And five years later, when he met Alex Binnie and his colleagues at the Into You tattoo studio in London, Lucky decided to cover all the random tattoos he'd collected and transform them into one all-over, black-ink body tattoo.

But even that wasn't enough. Since then, Lucky has had tattoos inside his mouth, inside his ears, inside places most people wouldn't think of putting a needle. He's even had white patterns etched onto his black body tattoo and, soon afterwards, colours over the white. Now some parts of his body have seven layers of ink scratched and re-scratched into them, and Lucky has also dipped his toe into other body modifications by getting a scarification (see page 62) to look as if a bear has clawed him. ➡

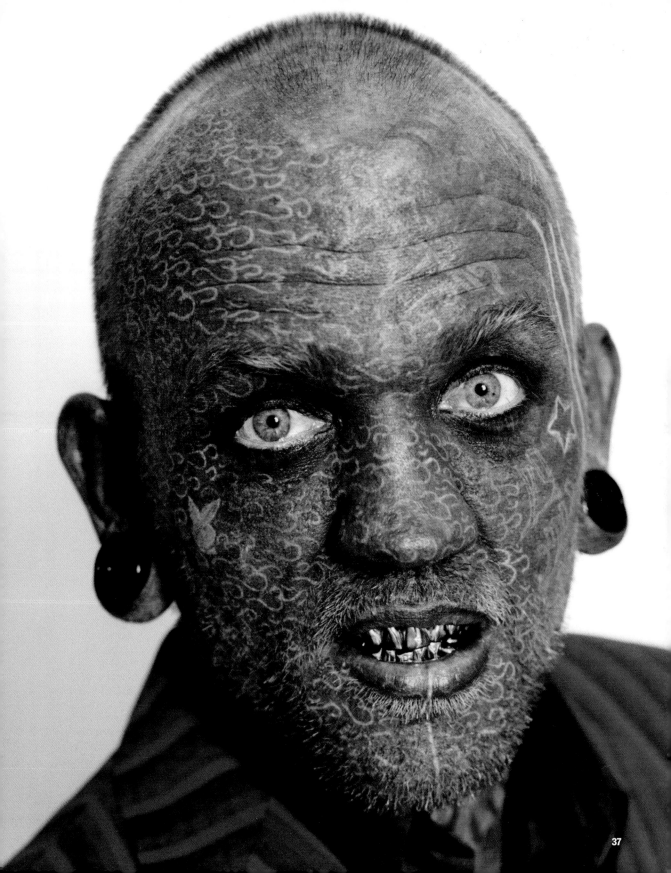

Tell us about your early life and joining the circus.

As a kid I'd done circus-style performances in the community where I lived in Australia, so it was a natural progression for me. I got an Australian Arts Encouragement Award to study with the equivalent of Canada's Cirque Du Soleil, the Flying Fruit Fly Circus in Albury Wodonga, which is a contemporary youth circus with no animals. I studied with them before working for a traditional circus, then went on to street performance because I like to travel, experience new cultures and meet new people. It became my lifestyle.

Was performing in your blood?

My uncle was an actor and an acting teacher, my dad was a boxer, as was my grandfather, and one of my uncles was a whipcracker. There's definitely a link with performing there, but I didn't grow up in that environment – I didn't meet my dad until I was 23, so I kind of found my way indirectly.

You once said that you consider your body to be a canvas, and you see yourself as an art collector, carrying around all this beautiful artwork. Then a few months later you started covering it in black. Why?

I'm a firm believer in being an artist, but also I feel art is transient, not permanent. A lot of people consider

"ART IS TRANSIENT, NOT PERMANENT. AND SO ARE TATTOOS"

tattoos permanent, but they're not. I don't believe there are any rules in art, and I'm interested in breaking those rules with other artists who have the same motivation as me. OK, so I collected all these amazing tattoos from artists around the world, and for some people it was the best art they'd ever seen – but the bottom line is that I collected them, I paid for them, and I covered them because I wanted to move on. My decision to go black is no disrespect to any of the artists. I found out it was possible to tattoo layers on layers, then discovered that Steve Herring and Xed LeHead at Into You in London were experimenting with white, and I thought it was the perfect opportunity to give it a go.

Why did you decide to go all black?

I killed two birds with one stone: I realised Tom Leppard, the previous record holder as the world's most tattooed man, hadn't gone 100 per cent tattooed, and I also thought it was the perfect opportunity to experiment with white ink and do something that hadn't been done before. If you go to any tattoo convention now you'll see dozens of people getting white tattoos on black – it's become very popular. I feel I was there at the start of something special, and I'm a kind of an advertisement for that.

Did people's attitudes towards you change after you went all black?

The reaction was more intense before I blacked myself in. After I did, people reacted in one of three ways: they thought I was a statue, they thought it was paint, or they thought I was a black person. It was kind of ironic because, when I spoke to Chuck Aldridge from ➡

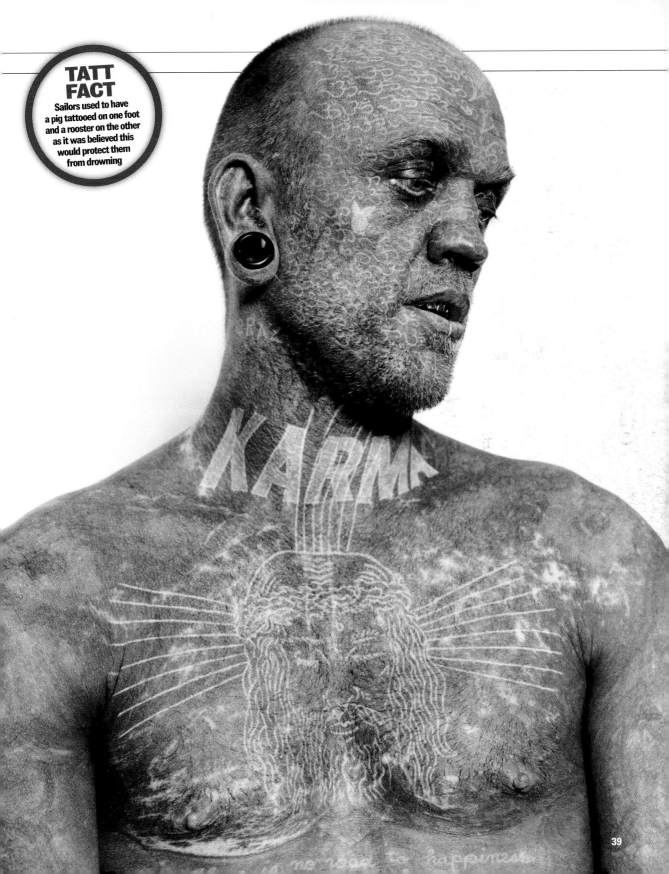

Inked Icon

TATTOO TIMELINE

LUCKY TAKES US ON HIS 18-YEAR JOURNEY FROM (ALMOST) CLEAN-SKINNED TO FULLY INKED

1988 "I'm 17 and have two tattoos – one on my arm and one on my hip. I'm fresh out of being in the circus (since age eight) and into the street-performing world, so I feel highly skilled but need to learn showmanship."

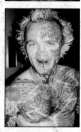

1994 "I'm starting to fill up tattoo-wise aged 23. I'm flying around the world, being rewarded for doing what I love – performing. I'm using tattooists all around the world to enhance my physical appearance."

1996 "Most of my body is tattooed at 25, so it's time to take the next step and get my face tattooed. My friends don't think this is a good idea, but I just do what comes naturally to me."

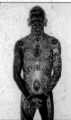

2001 "It's 2001, I've just turned 30, and my entire body is covered in designs I've collected from all over the world. I've used dozens of tattoo artists, each with varying techniques."

2002 "It's just before I started to black over my first bodysuit. I'm thinking about the possibility of covering my body up 100 per cent in black ink to take the world record, and also about tattooing white ink over the top of the black."

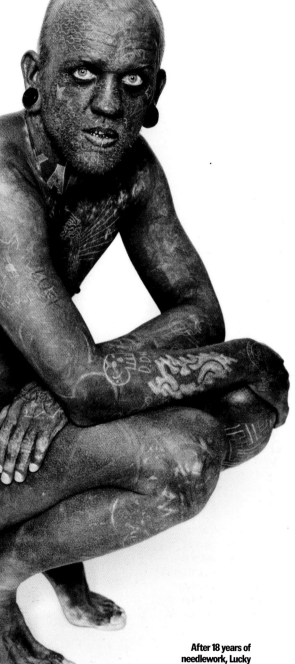

After 18 years of needlework, Lucky Diamond Rich is the world's most inked man

Tattoo Archive [Tattooarchive.com], he told me that with the Great Omi [legendary tattooed man from the first half of the 20th century], people thought he was a white person with black stripes, rather than the other way around. It's interesting to see how attitudes have shifted.

What's your newest tattoo?

It's the word 'Karma' on my throat, by Xed. We're experimenting with lines and shading in white. I've also had some subdermal implants put in my chest

"I'VE HAD OVER 1,150 HOURS OF TATTOOING IN SEVEN LAYERS"

by Lukas Zpira – two Teflon rods. I'll be using them for performances, like pulling a truck or stuff like that. Lukas also did the bear scars on my head.

What's next for you now that your world tattoo record has been officially recognised?

As far as my tattoos go I'm multi-layered, so the coverage is more than 100 per cent – it's been worked out as being 220 per cent if you count the layers. There's 1,150 hours of tattooing, and in some areas there are six or seven layers. Maybe I'll try a new record attempt. It'll be later this year, but I'm not sure what I'll do yet. I don't want to be too specific at this stage, but I have a few ideas of which records to attempt to break for years to come. There are a lot of records I could break, but whether it'll be in the circus or tattooing you'll definitely see my name there. ⓑ

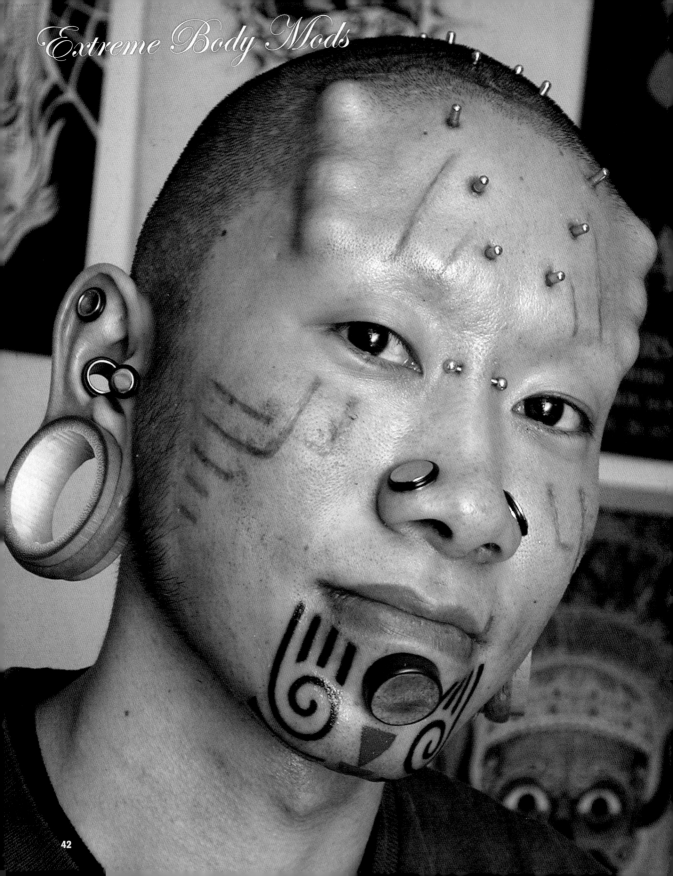

UNDER YOUR SKIN

FANCY A CROWN OF HORNS? PERHAPS A FACEFUL OF BALLS? HOW ABOUT A METAL MOHAWK? STEP RIGHT THIS WAY...

WORDS **JAMES DOORNE** PHOTOS AND CAPTAIN HOWDY INTERVIEW **ASHLEY/SAVAGESKIN.CO.UK**

Anyone wanting to modify their body has a greater choice of procedures now than ever before. Not long ago your choices were limited to a permanent drawing on your skin or a piece of metal piercing your flesh. But over the last few years, 3D implants have enjoyed a dramatic spike in popularity. So much so that one estimate puts the number of people who have at least one at more than 50,000. It's fair to say that the new demand for 3D implants is changing the face – and a lot more besides – of body modification.

Steve Haworth is a body mod legend. He's credited with inventing subdermal implants, and even if you don't know his name, you'll probably recognise his work.

The content on Steve's site, Stevehaworth.com, is so extreme that it carries a warning, reminding visitors that they might not like what they see. The warning is followed by an explanation of Steve's approach to life: "One person's idea of driving is taking a leisurely cruise, another person's is getting behind a 5,000-horsepower dragster and doing 400mph in six seconds," it says. "Obviously, racing is the extreme end of driving, but that doesn't make it wrong. One person's idea of body-modification is going to be a pierced earlobe; another person's is to look like *el diablo*. Just because you don't agree, doesn't make it wrong."

Steve is definitely in the 5,000-horsepower dragster doing 400mph.

"My background was in medical device and implant design for plastic surgery," he explains. "I thought if we could give someone more defined cheekbones, why couldn't we give them horns?"

And although in time Steve would give people horns – and he's now done so many implants that he's lost count – his first subdermal implant was a simple procedure for a woman who asked him for a bracelet, but something a little different to ➡

PICTURES: STEVE HAWORTH, SAMPPA/MADMAXTATTOO.COM & VOINCYBORG.COM; BMEZINE.COM; QUENTIN/KALIMA.CO.UK; MAC MCCARTHY/PUNCTUREDBODYPIERCING.CO.UK

your normal plastic bangle. That gave Haworth the ideal opportunity to implement an idea he'd been considering for the last six years, and he suggested a subdermal implant in her wrist. She loved the idea, and the rest is history.

MOD DEVELOPMENT

While something as simple as a subdermal bracelet has become routine, Steve continued to experiment and eventually created one of the most sought-after 3D body mods: a strip of implants along the centre of the head, to which you can attach studs, horns or whatever you like depending on the occasion and how you want to look. He calls it the metal Mohawk and it's been copied a lot. World-famous

Right: Paula, a nurse and apprentice body piercer, was the recipient of Captain Howdy's first implants

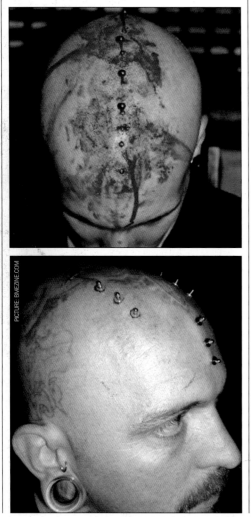

PICTURE: BMEZINE.COM

Top: The immediate aftermath of a metal Mohawk installation

Bottom: Transdermal implants, four months into the healing process

"THE LAST THREE HOURS OF GETTING MY METAL MOHAWK FUCKING HURT"

performance artist and body-modifier Samppa Von Cyborg (see page 80) is one of many people who saw it and had to get one of their own.

"When I first saw pictures of the metal Mohawk, I knew it was what I wanted," says Samppa. "I haven't had any negative comments. Lots of people say they couldn't do it because of their job, but they'd like to because it looks cool."

The metal Mohawk consists of 15 separate points down the middle of his head that accept different attachments. They're "sort of permanent" according to Samppa, meaning he could have them taken out if he wanted. But it wouldn't be easy.

"There's a little plate under the skin and a post comes through the surface," Samppa explains. "Around this post are holes which anchor the plate under the skin so it doesn't spin when you screw something in."

Stability is given by the scar tissue that grows through the metal plate and around the post, and you can add anything you want to them. Samppa uses three or four attachments, but he makes body-art jewellery and reckons there are at least 15 different adornments you can buy.

But wearing the larger attachments isn't without risks. On the plus side, you won't get pigeons landing on you – but it can be dangerous.

"When I started wearing spikes, I hit my head many times," admits Samppa. "You can wear them 7cm long, but it's not a good idea to wear big ➡

See more of body mod artist Thorsten's work at Myspace.com/bodydeco

If you want a metal Mohawk, your body modifier isn't allowed to give you an anaesthetic

Brazilian body modifier Gerson de Araujo Nobrega Grandson, better known as Urea, has spectacular arm implants

TATT FACT

Long before the days of laser surgery, tattoos – and several layers of skin to boot – were painfully scrubbed off using sandstone

"I'm trying to create myself as a comicbook or animal hero, hence my name," says body mod icon Baawo Bee

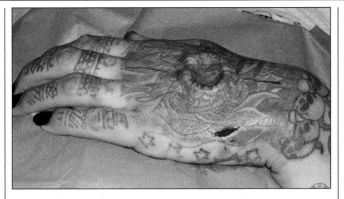

"GETTING IMPLANTS UNDER YOUR SKIN IS NOT FOR THE FAINT-HEARTED"

as "inspired by sci-fi characters from *Star Wars*, *Star Trek* and other films". He recently had silicone implants installed under the skin around his eye sockets, partly because it was "more organic-looking". The balls are made of silicone, which is lighter than Teflon – an important consideration for facial implants. At the time of writing, he's the only person in the world who has this particular implant.

"I always wanted to get something on my face, but I wasn't sure what," he says. "But when I met body-mod artist Howie, he had ideas coinciding with mine. Originally we considered implants above my eye, but this had been done before. So we decided to go for this design, which frames my eye socket. Howie made one incision under my hairline, just above the ear, then he made a pocket towards the eye with a dermal elevator. This was split into two, one below and one above the eye. We then inserted the implants under the dots ➡

spikes if you're going clubbing. When you have long spikes you forget you have extra height. And if you have long spikes and hit them it makes much more damage than small spikes."

Samppa can now install a metal Mohawk in a little under 45 minutes but, as he couldn't do his own, his apprentice stepped in and did the work… which took more than four-and-a-half hours. "It was his first attempt, so he made more damage than necessary," says Samppa. "The first two hours didn't hurt, but the last three were fucking painful."

LOOK NATURAL

For all the people who love Samppa's implants, there are those who wouldn't consider them because they don't look natural. Currently there's a heated debate about the aesthetics of implants, with some feeling that the best implants are the ones that look natural – an extension of the person rather than an obvious bolt-on. There are also those who are taking implants into the realms of sci-fi and fantasy. Steve says his dream implant is "a sagittal crest, a Klingon feature from the show *Star Trek*". And he's not the only person using sci-fi as a template for body modification.

Captain Howdy is a body-mod practitioner and freakshow performer who describes his look

Implants on your head aren't limited to metal Mohawks

EYEBALL IMPLANTS

In 2004, specialists from the Netherlands Institute for Innovative Ocular Surgery (NIIOC) in Rotterdam implanted 3.5mm-wide pieces of platinum jewellery into the eyes of six women and one man.

The eye-watering procedure, known as a cosmetic extraocular implant, takes about 15 minutes to carry out and involves the jewellery being inserted into the eyeball's mucous membrane, once a local-anaesthetic eyedrop has been used to numb the eye.

Patients can choose to have a personal shape made, or they can select from the ones that are already available, which include a heart, a star, a half-moon, a Euro sign, a four-leaved clover and a musical note.

NIIOC director Gerrit Melles says, "This new procedure is a bit of fun, and a very personal thing for the people who have it done."

Above and right: Captain Howdy gets implants inserted around his eyes by body mod artist Howie

we'd marked and positioned them correctly. Then Howie sutured the incision. I couldn't see much, but I could see my skin being lifted up and down and felt the pressure. It's not for the faint-hearted."

MICRODERMAL PIERCINGS

If there's such a thing as an implant for the faint-hearted, it would be a microdermal piercing.

Microdermal piercings – also known as a 'surface anchor' or 'dermal anchor' piercing – is one of the latest advances in body modification. They're not for cowards exactly, but they allow you to achieve the aesthetic of a transdermal piercing without the pseudo-surgery. Since their debut at the Association of Professional

Piercers' Conference in Las Vegas in 2006 as a prototype developed by Pat Pruitt from Custom Steel Body Jewellery, they've become more popular by the day. Shannon Larratt, founder of Bmezine.com and body modification legend, described microdermal implants as "arguably the biggest development in body-piercing in 2006". They're also the most versatile piercing a person can get, and can be put pretty much anywhere on your body, in any kind of tissue.

Reverend Keith Roman has been performing microdermal piercings at Kyklops Tattoo in Pittsburgh, Pennsylvania, for nearly a year.

"A microdermal implant is a piece of jewellery made to be mostly implanted into the subcutaneous layer, with just a little bit sticking out that you can attach different ends to," he says. "They're created using a needle and no surgical instruments, as opposed to the larger subdermal implants."

Basically, a piece of metal with a flat base is inserted under the skin. It has holes in it, through which the skin grows, anchoring the implant to the body. And the process is simple.

"It's extremely comfortable," says Reverend Keith. "Most people think it hurts, but I believe mine hurt less than most regular piercings.

"First, the area is cleaned with a surgical scrub and marked, and given a massage to loosen up the tissue. Then, using a needle, a 'pocket' is made by going in a certain depth, then over a certain length, and the needle is removed. Then the implant is inserted. I like to do them with the end threaded onto the implant as it makes for easier insertion.

DIFFERENT TYPES OF IMPLANTS

IF YOU WANT TO BE PART OF THE BODY MODIFICATION REVOLUTION, YOU HAVE THREE BASIC IMPLANT OPTIONS: SUBDERMALS, MICRODERMALS OR TRANSDERMALS...

Subdermal implants are housed completely under the skin to give a raised appearance.

Transdermal implants appear partially under the skin, and partially above it.

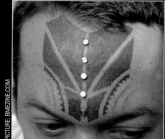

PICTURE: BMEZINE.COM

Microdermal piercings are similar to transdermals, but much smaller and easier to insert.

Each implant has its own appeal. Some people like subdermals because they look organic, others prefer transdermals because they're more extreme, and microdermals are the least hassle.

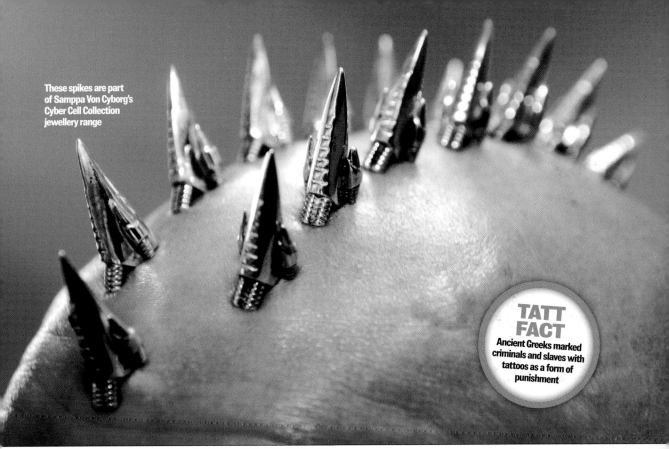

These spikes are part of Samppa Von Cyborg's Cyber Cell Collection jewellery range

"What you're left with is a point with a thread, into which you can screw whatever you like.

"The ones I use are 14-gauge, and can accept any internally threaded end with a thread size of 1.2mm, which makes choosing an end to wear on them a joy since there are so many things you can choose – gemmed decorations, coloured balls, spikes, half domes and so on."

But while microdermals are the hottest thing in body mods, that won't last long.

As Captain Howdy puts it: "Nowadays, the options are endless, and people are changing their entire bodies. The only limit is imagination."

And people are already working on the next generation of implants. As reported in our feature on functional implants (page 132), people have had RFID chips, which can interact with computers, inserted under their skin. Steve says he has "many concepts in the works", but Samppa has more specific ideas.

"I think in the future you'll be able to get any kind of

"YOU CAN CHANGE YOUR WHOLE BODY. THE ONLY LIMIT IS YOUR IMAGINATION"

functional implant. I think the medical industry and the body-modification industry will meet. In the future, things you get as a medical necessity now will be available for purely cosmetic reasons."

Outside of aesthetics, Samppa wants to make a vibrating implant "in the cock" so it'll vibrate like a dildo, but sees a future where functional implants are also used for aesthetic reasons.

"I'm working with a kinetic power generator. I want to make functional implants that do something, not just look good," he says. "That means that when I have that generator I can make LED lights under the skin. They won't be visible, but when you start clapping, for example, or when you move your arm, it'll generate power and the LED lights will start flashing. That will allow me to make next-generation tattoos." Ⓑ

BIOMECH

BIZARRE READERS SHOW THEIR INNER WORKINGS TO THE REST OF THE WORLD

PREACHER MUAD'DIB
Who did it?
Sean Zulu at Zulu Tattoo, Dublin, Ireland.
What is it? Biomech in HR Giger style.
Why did you choose it? It integrates with the transdermal implants and flesh staples in my arm. But after this photo was taken I was in a bike crash, and now the majority of my piercings are gone.

FAYE MARIE SIMCOX
Who did it?
G. Carnelly at Octopus Tattoo, Derby, UK.
Why did you choose it?
I thought dragon wings were different to the angel wings you normally see.
How do you feel about it now? I love the way the wings look as if they're coming out of my back.

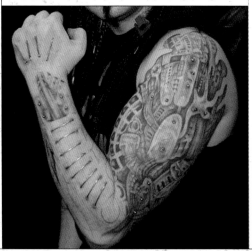

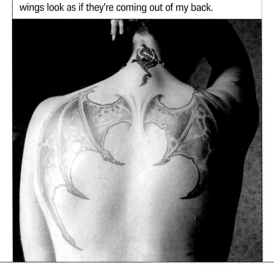

PAUL BREMNER

Who did it? Ben Boston at Bristol Tattoo Studio, Bristol, UK.

Why did you choose it? I wanted a work of art that I'd always be proud of. This tattoo combines a lot of ideas that are very much part of me, as well as imagery I love such as robotics and science-fiction.

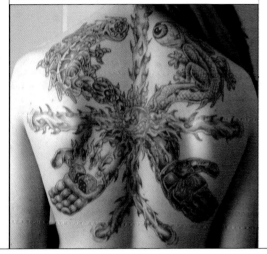

DJ DES CAS DANSENT

Who did it? Sylvain Keuns at Tin-Tin Tattoos, Paris, France.

What is it? Original aliens by Sylvain Keuns.

Why did you choose it? Because I love electronic implants, cyberpunk and HR Giger artwork.

How do you feel about it now? I need more! ➡

DAVID OWENS

Who did it? P Hamilton at Kaya Tattoos, Glasgow, UK.

What is it? A biomech skull.

Why did you choose it? The rest of my sleeve is flames and an HR Giger-style biomech background, so I thought it would fit in.

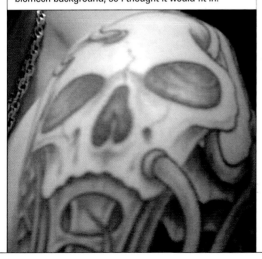

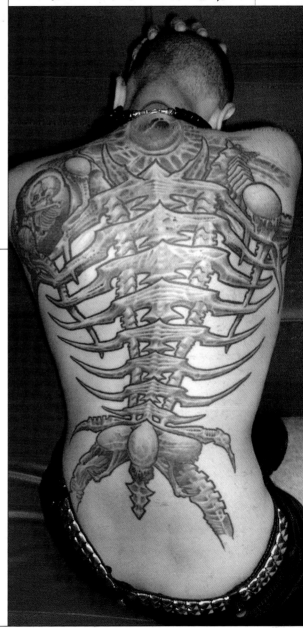

Your Tattoos

MICHAEL TOAD
Who did it? David 'Skull' Bingham
at my sister's house.
Why did you choose it?
I always wanted wings. I also have a skin
rip design because I like the look of open wounds.
How do you feel about it now?
I love them, and I have plans for more. I can't wait.

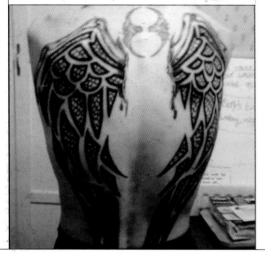

DAN LIVESEY
Who did it?
Ginny at The Ink Pot, Oldham, UK.
What is it? A biomech Medusa I saw
on a T-shirt Spiral Designs created.
Why did you choose it? At the time I was unaware
I was about to have this tattoo – it was a birthday
surprise. It hurt like a bastard, but I still love it.

SARAH TOLLEY
Who did it?
Mark Gibson and Andy Bowler at
Monki Do Tattoo Studio, Belper, UK.
Why did you choose it?
I loved the idea of a biomech spinal cord going down
my back, so that's what I had.
How do you feel about it now? I fuckin' love it!

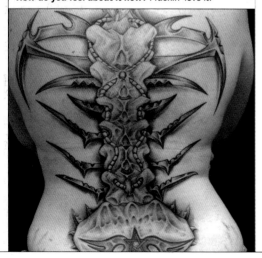

SIMON REYNOLDS
Who did it?
Andy Jones at Voodoo Tattoo, Preston, UK.
What is it?
A facehugger from the *Alien* films.
How do you feel about it now?
I'm having a few bits and pieces added to make it look
even more realistic – blood, ooze and so on.

ALICIA

Who did it? Adam Collins aka 'Adam the Punk' at New Wave Tattoo Studio, London, UK.
Why did you choose it?
I just love the artwork.
How do you feel about it now?
I'm proud to be wearing some of Adam's work.

SPENCER RICHARDSON

Who did it?
Mark Jarvis at Body Artz, Petersfield, UK.
What is it? A spiked spine.
Why did you choose it?
I wanted a nice big piece on my back, and I thought a biomech spine would look really good. I didn't want something that was purely anatomical.

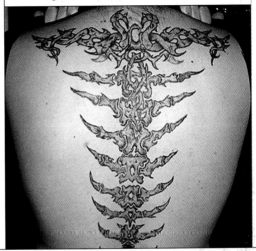

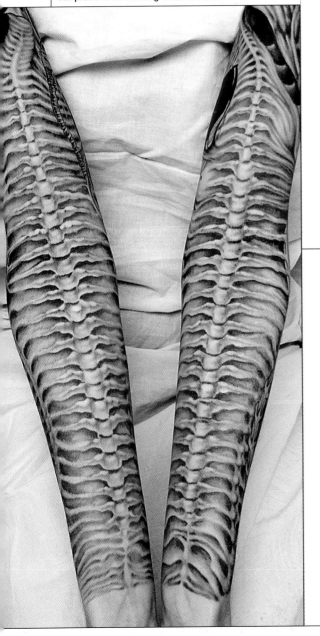

ALEK WEST

Who did it?
Dave at Moving Pictures, Cambridge, UK.
What is it? A Japanese dragon merged with biomech elements, bones and wind.
Why did you choose it? I love the detail and depth, and I can always add more to it.
How do you feel about it now? Love it. Ⓑ

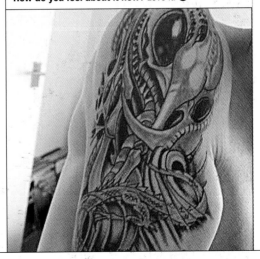

KAT VON D

MEET THE TV TATTOOIST WHOSE CELEBRITY CLIENTS INCLUDE MY CHEMICAL ROMANCE AND BAM MARGERA

WORDS AND PHOTOS **ASHLEY**

Kat Von D is one of the most respected tattoo artists in the world. Best known for appearing in two seasons of the reality-TV show *Miami Ink*, Kat has recently opened a new tattoo shop in West Hollywood, California – High Voltage Tattoo – which is the focus of her *Miami Ink* spin-off series, *LA Ink*.

A notorious party animal, Kat's whirlwind life in the City of Angels' clubs and bars has helped her land a succession of high-profile jobs, including ink work for famous actors, athletes and musicians, many of whom have commissioned her signature black-and-grey portraits. To date, Kat's celebrity clients include *Jackass*' Bam Margera, Ryan Dunn and Steve-O; rockers Slayer, My Chemical Romance and Green Day; and professional skater Mike Vallely.

While Kat has always been close to her parents and siblings, it was her grandmother – a professional pianist in Germany – who first turned Kat on to the arts. Pushing her to take piano lessons, Kat's grandmother introduced her to some of the great composers, including Beethoven, whose work she immediately fell in love with. This in turn inspired Kat to discover other musicians, painters and sculptors from the same era, many of whom have left an indelible mark on her work.

However, it was Kat's discovery of punk rock music as a teenager that changed her life forever, and she became increasingly immersed in its culture and lifestyle. At the age of 14 she got her first tattoo – an old English 'J' on her ankle, a memento of a long-lost love. Shortly afterwards, Kat did her first tattoo for a friend – a skull based on the logo of alternative rockers the Misfits – and ironically ➡

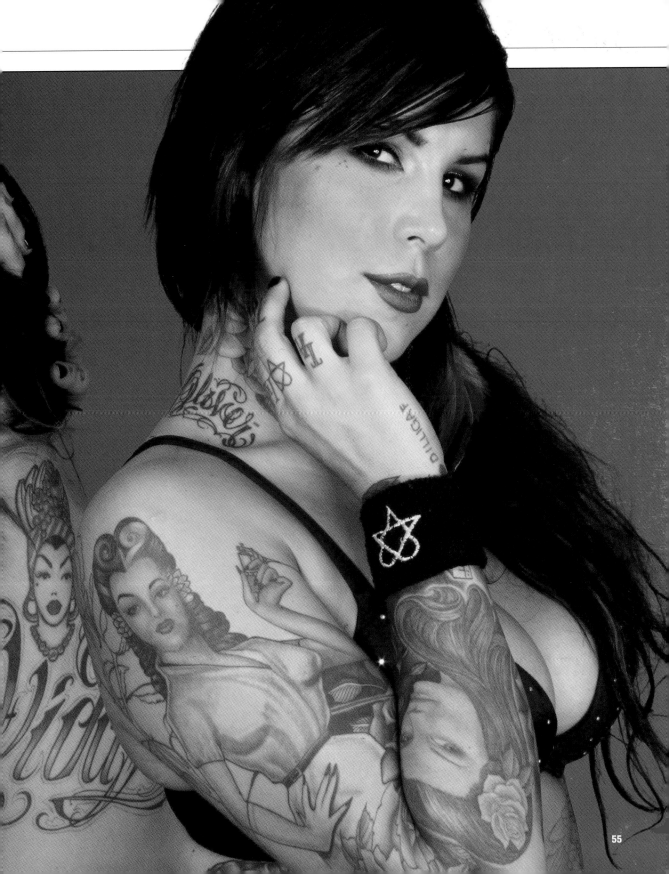

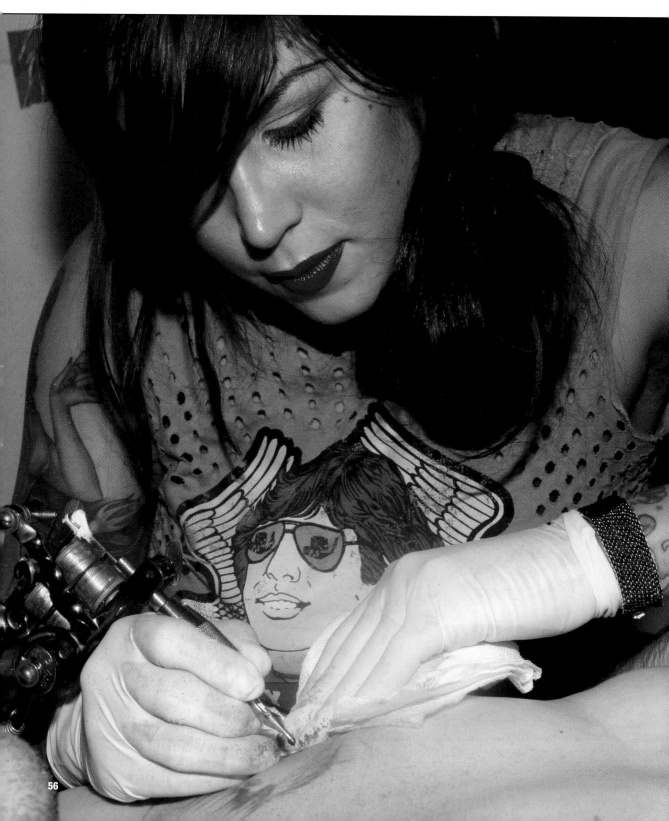

she ended up tattooing one of the original members of the Misfits a few years later.

By the age of 16 Kat was working at tattoo shops in and around LA. A few years later she was at True Tattoo in Hollywood, working alongside notable artists Clay Decker and Chris Garver, who in turn brought her into the *Miami Ink* show. There, under the watchful eyes of the TV cameras, Kat honed her signature style, developed a devoted following and came into her own as an artist.

Where were you born and where did you grow up?
My family is originally from Argentina. However, because my parents are missionaries for the Church they ended up moving to Nuevo León in Mexico, where my brother, sister and I were born. When I was about four years old

"I ACTUALLY HATE GETTING TATTOOED MYSELF. I'M NOT GOOD WITH PAIN"

we came to North America, and since then I've lived pretty much all my life in southern California. My time living in Mexico and Mexican culture has definitely influenced my artwork a lot. I specialise in fine-line black and grey tattoos, and a lot of that stuff originates from Mexican prison-style artwork. And just walking around Los Angeles you see murals everywhere – you see the low-riders, you see gangsters, and all that stuff has also played a big part in what I do.

When did you become aware of tattoos and decide that tattooing was the career choice for you?
When I started hanging out with punk kids – I was about 14 at the time – there was a friend of mine who did lots of tattoos, the unprofessional kind. He was always coming round and tattooing us, and because he knew I was artistic and was always drawing, he suggested I tattoo him. So I did, and that was the first tattoo I ever attempted. Since that day tattooing has been what I wanted to do, it just seemed natural for me. And when the opportunity to pursue it as a career landed in my lap, I naturally gravitated towards it.

How did things continue from there? Did you do an apprenticeship?
When I first started out I was underage, and it's illegal for anyone under 18 to get tattooed in California, let alone tattoo anyone else. But I had a lot of underage friends who wanted to get tattooed and that made it easy for me to practise. So by the time I was 16 I got into my first tattoo shop, and that was when I had to unlearn ➡

One of Kat's clients goes under the needle at the 2006 London Tattoo Convention

a lot of the things I'd been doing. That's where I learned about all aspects of tattooing such as sterility, needles and machines, things I really had no clue about.

Tell us something about the tattoos you have.

I like to get portraits of people in my family, and feminine stuff, too – things I enjoy looking at. I don't necessarily think every woman should get as heavily tattooed as I am – for me, this is a profession and a lifestyle. I'm in this for the long haul. I'm going to be a tattooist until my hands drop off! That said, I actually hate the process of getting tattooed; I'm not good with pain, so I can't sit very well for long periods. I pretty much always dread getting tattooed, but when I see the end result it's worth it. Eventually I'll have a full bodysuit, although I'll probably leave my chest alone.

How did you become involved with *Miami Ink*?

The network had been wanting to add a female artist to the *Miami Ink* crew for some time and Chris Garver, who owns the shop where I used to work in LA, vouched for me. And that's how I got on the show.

Let's talk about the clients you worked with on *Miami Ink*. Obviously, most of them were chosen for their stories…

In order to make an entertaining show, you need to have good stories. In real life, tattooing isn't always as therapeutic as it gets on *Miami Ink*. However, I do a lot of emotional tattoos where people actually get moved and cry, and that can be pretty tough. It actually makes my job harder. But, ultimately, my job is not to be a therapist, but to do a good tattoo.

How did you get on with the other *Miami Ink* crew members? Did you get on with everyone?

Chris Garver was pretty much my only real friend when I was in Miami. He used to be my boss when I was in

The Miami Ink crew (left to right): Yogi, Ami James, Chris Nuñez, Darren Brass, Kat Von D and Chris Garver

LA, so he was like a brother to me. Everybody else on *Miami Ink* was really nice apart from Ami, who I had a hard time getting along with – he's just real hard-headed, and that comes across in the show. But our relationship brought a bit more drama to the show. Offscreen, we never used to talk unless we had to for work. I did all I could to be friends with him, but it didn't work. But I always used to respect the fact it was his shop, and do whatever I could to make the ride a little smoother.

What do you think you brought to the show?

With all the testosterone in the show, there was definitely a need for some oestrogen! Also, some people can relate better to a woman tattooist, though I've always tried not to make my gender an issue and to let my work speak for itself.

Do you think you might provide a role model for those women wanting to work in the industry?

I'm not here to convince people to move into the industry, which is already saturated, but I'm definitely here to try and open up people's minds. If that results in women who are tattooed being more readily accepted and respected, that's great. After all, I know so many heavily tattooed women who are great mothers, wonderful teachers, wonderful people, and I think it's

"I'M GOING TO BE A TATTOOIST UNTIL MY HANDS FALL OFF. IT'S MY LIFE"

time for the world to know about it. Being a female tattooist has caused some people to doubt me based on my gender, but if you're a good tattooist and give your work 110 per cent, you're going to blow people's minds, no matter what sex you are. It's always about the work.

Have any particular stories impacted on you?

When you spend long periods of time tattooing someone and they tell you their story, it's hard not to get involved with what they're going through. I think what tortures me most is when I have to tattoo portraits of children who've passed away – that's the worst thing, to have a parent outlive their child, something nobody should have to go through. People often get tattoos for closure. It's all about whatever heals. **ⓘ**

To see more of Kat's work, check out her website, Katvond.net. Kat has been tattooed by over 30 artists, including Chris Garver, Peter Castro, Kore Flatmo and Jack Rudy. The left side of her body was tattooed primarily by Jim Hendricks

TATTOO

TATT FACT

Martin Hildebrandt, a German immigrant, was one of America's first professional tattooists. During the Civil War he was famous for inking both Confederate and Union troops

BUSINESS HOURS

MON.	2:00 PM	TO
TUE.	2:00	TO
WED.	2:00	TO
THU.	2:00	TO
FRI.	2:00	TO
SAT.	2:00	TO
SUN.	2:00	TO

323-162-47

KAT VON

Kat's fine-line tattoos are a fashion essential with LA's celebrity set

Cutting Crew

Captain Howdy gets down to the serious business of cutting

SCARRED FOR LIFE

TAKE A DEEP BREATH AND RELAX, AS A MAN WITH A RAZOR-SHARP KNIFE CARVES INTRICATE PATTERNS INTO YOUR FLESH. THIS IS SCARIFICATION

WORDS **JAMES DOORNE** PHOTOS AND RYAN OUELLETTE INTERVIEW **ASHLEY/SAVAGESKIN.CO.UK**

As tattoos edge ever closer to being a mainstream fashion accessory, the early-adopting kids of body modification have been trying out something different instead: scarification.

Scarification – intentionally scarring another person's body – started as a ritual act. In its first incarnation as a tribal rite, it was characterised by broad strokes, thick lines and chunky raised scars, which had a symbolic meaning but little fine detail. Over time, fresh techniques developed and transformed scarification. Now a new generation of body-modification artists have created scars to rival tattoos for clarity and detail.

"I like how scarification is more organic than a tattoo," says Ryan Ouellette, one of the top scarifiers in the world, who works at Precision Body Arts in Nashua, New Hampshire, USA. "When you tattoo, you put something into the skin; with a scar, it's just the body."

Ryan started experimenting with scarification by cutting himself, mostly on his legs – "making little patterns and designs using a needle head or anything else sharp" – before trying different, more precise pieces.

"The stuff I did when I was young was generally little astrological signs, small geometric stuff, nothing elaborate," he says. "In the early days of scarification, most of the designs I saw were quite boring, just small lines, curves or circles. And it made me think about why people weren't trying something more interesting."

Now, the designs Ryan was dreaming of 20 years ago have become almost routine. ➡

PICTURES: RYAN OUELLETTE, RON GARZA, JOHN DURANTE/LAUGHINGBUDDHATATTOO.COM.

MAKING THE CUT

John Durante, a scarifier at Laughing Buddha Studios in Seattle, USA, has been cutting people for the last 12 years, and he says that recently scarification has become "ridiculously popular".

"I remember back in the mid- to late-90s scarification seemed much more of an underground phenomenon," he says. "Nowadays, it's definitely getting more and more popular. I wouldn't say it's become mainstream just yet, but there are tons of enthusiasts all over the world."

John uses two types of scalpel for the different types of incision required in most scarifications: "A number 15 scalpel is a snubnose, rounded-tip scalpel that's good for curves and edges, and a number 11 is a standard scalpel, not rounded at all. They're pretty typical blades for most scarification artists."

"SCARIFICATION IS VERY POPULAR. NOT MAINSTREAM YET, BUT CLOSE"

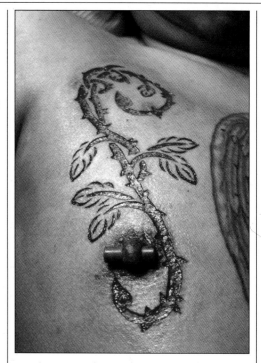

Broadly speaking, there are two different methods of scarification: line-cutting and skin-removal, both of which are done with a carbon-steel surgical scalpel.

For a 'line cutting', you cut through the top of the skin, making single incisions down to the mid-dermis, and no tissue is removed at all. But the initial incision has to be a cautious one, as the tissue's consistency is vastly different from place to place on the body. ("You really don't want to open someone up uncontrollably with a first incision," one scarifier told us.) And you need to maintain an even depth.

After the cutting, if you keep the cut open with good aftercare, eventually the new tissue that grows to close the cut has no melanin, and will be pink to start with and then go white over time. The contrast

Ryan Ouellette, one of the world's top scarifiers

between the scar tissue and the regular skin is how the design is made.

Skin-removal (the method that leaves curly, Quaver-like skin pieces as a by-product) is much the same. The only difference is that you have to make two shallow parallel cuts and remove the tissue between them. That can be any amount you like, but commonly between a couple of millimetres and a couple of inches, depending on what kind of design you're looking for. After cutting you can agitate the scar to make it rise, try to make it go partially inverted, or simply leave it alone, depending on what you want the final scar to look like.

TREATING YOUR SCAR

Quentin, from Kalima Studios in Worthing, UK, is a professional scarifier. When he had his first scarring done he wanted a special look that could only be achieved with some extreme aftercare.

"My first scarification was on my arm; I had my daughter's name done in runes," he explains. "I've always envisaged runes being carved out of rock, so I wanted the design 'sunken' in my skin. I felt scarification was the best option, but as I wanted to keep a carved look, I developed a technique of brushing the wound as the scar healed, so my ➡

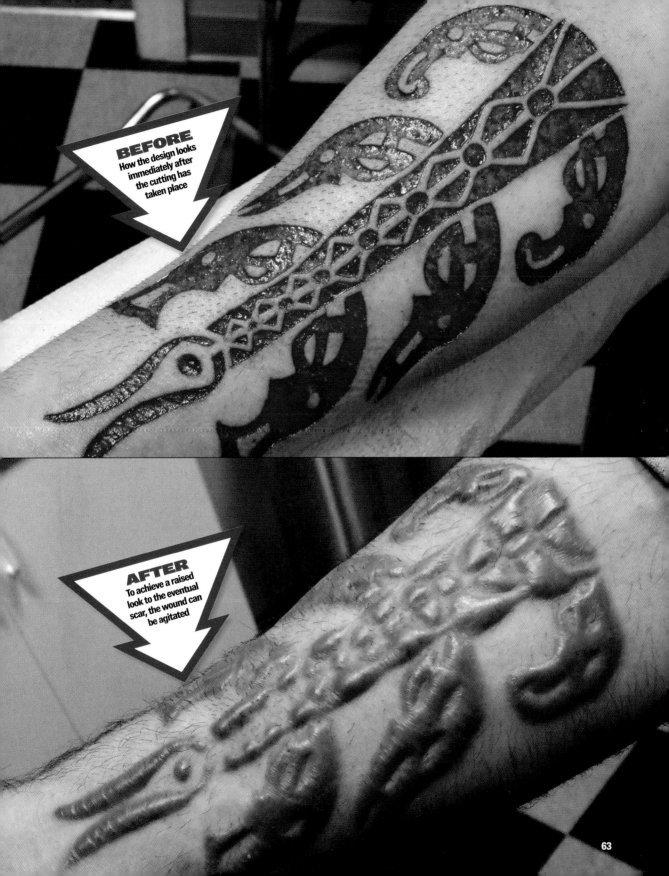

BEFORE
How the design looks immediately after the cutting has taken place

AFTER
To achieve a raised look to the eventual scar, the wound can be agitated

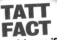

TATT FACT

A tattoo of the crucifixion on a slave's back during the 1700s was said to save them from a lashing, as their captors couldn't bring themselves to whip Christ

scars go in and not out. A lot of people irritate their scars to get them to raise, but I wanted mine dipped, so they actually go *into* the skin.

"I brushed my scars for three days with lemon juice and a toothbrush, and removed the lymphing [the white blood cells you secrete when healing, which partially make up a scab]. As I don't lymph much, after three days I got a dipped scab that healed. Then I spent a few months rubbing any regrowth out.

"The lemon juice is the bit most people find uncomfortable, and the first time I did it I jumped around for about 15 minutes swearing my head off. Some people have nearly passed out because of the pain, but I've never found it that bad. You're not trying to irritate the scars so much it bleeds. Using a power shower is also good as that softens the lymphing up and scab tissue naturally starts to come away from the skin."

FEEL THE PAIN

The pain aspect of scarification is interesting. According to Quentin, although a lot of people are attracted by the organic aesthetic of a cut, the prospect of pain puts them off. "I think when you mention cutting or branding, lots of people subconsciously imagine someone coming at you with a hot piece of metal, almost like Sweeney Todd the barber slashing at people," he says.

But there are pain junkies who love just that, and there's something hardcore about getting an artist to cut you for two hours in a 'blood ritual'. For some, the sustained discomfort is an integral part of scarification's appeal.

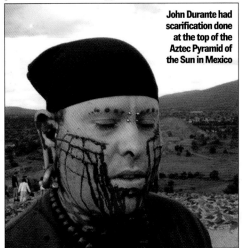

John Durante had scarification done at the top of the Aztec Pyramid of the Sun in Mexico

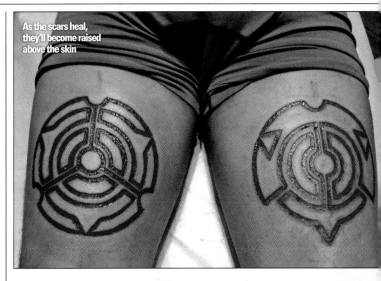

As the scars heal, they'll become raised above the skin

"PAIN IS VITAL. IN THE END, IT MAKES THE WORK MORE SPECIAL"

John, who had scarification done on his face at the top of the Aztec Pyramid of the Sun, at Teotihuacán in Mexico, admits scarification can be painful at the best of times, and says he occasionally questions people's motivation when they come to him. "A lot of people approach it in an unhealthy manner," he says. "You have plenty of sadomasochists that, instead of sitting cutting themselves, will pay an artist to do it for them. I never like to contribute to somebody's illness."

Ryan, too, admits he often gets people coming to him with the wrong idea about scarification: "There are some people who want work purely for the shock value, or want to rush into getting work for no good reason. If a person isn't ready for it or wants it for the wrong reasons, I'll refuse them."

But a lot of people are somewhere in the middle. The pain might not be their motivation, but makes it more worthwhile.

"I don't think people should be able to get a cutting and it be painless, as there would then be nothing special about it," says Ryan. "I sometimes use an anaesthetic gel, but people still feel it and that's part of the process. That's also what makes it interesting when you see people with large-scale scarification work, as it really shows what they had to go through in order to get to that stage." ➡

John Durante scarified musician Garland during a guest slot at Infinite Body Piercing in Philadelphia

"IF THE CUTTING MEANS A LOT TO YOU, YOU'LL REACT LESS TO THE PAIN"

And that's more pronounced in different cultures. When Ryan was in Japan a couple of years ago, it was so different it was almost surreal: "I went to Japan in 2005, and when I did cuttings everyone sat perfectly still – no whining, no crying. They wanted the art and they realised to get something like that, it hurts. I think the more the cutting means to someone, the less they'll react to the pain."

The pain factor also makes scarification a more intense experience for the cutter. "It's quite a personal thing between two people," says Quentin. "Maybe it's because we don't do it all the time. I really enjoy cutting. I really, really enjoy it. It's quite a special thing to do."

And John agrees: "It takes a lot more out of you, because you know you're going to be putting someone through pain for maybe two hours. I want to achieve a beautiful scarification piece for my client in the most efficient manner, but I'm also trying to move right along. I know what pain they're going though."

As cutting becomes more popular, and possibly mainstream, new developments will have to be made for when some simpering celebrity is showing off his scarification on *Popworld*. Already people are fusing tattoos, scarification, branding and other body mods together in the same piece.

"It's an exciting time," admits Ryan.

And Quentin has been scarifying tattoos for a while already. "For a few years I've been burning out black tattoo work so you get white scars inside the black, totally removing the ink," he says. "It's something I've worked on. I've done a friend's whole leg – he'd blacked his whole leg in – and I burnt stars out of it, so he now has white stars inside the black. That was always possible, what limited us was thinking, 'Can we do it?' It's like anything; the only thing that really limits us is what we think is possible." Ⓑ

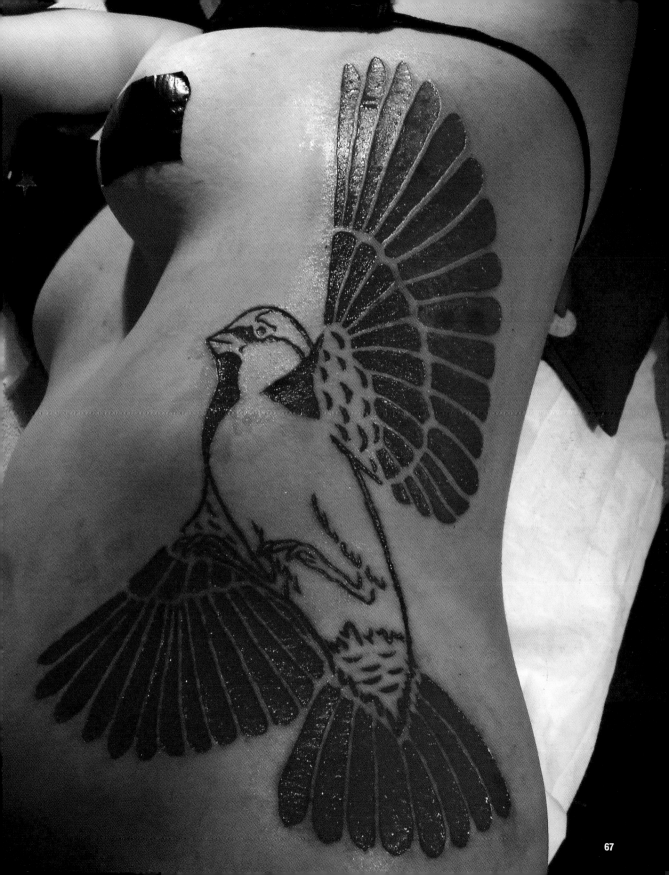

HORROR

FROM LEGENDARY MONSTERS TO FRIGHT FLICK VILLAINS, *BIZARRE* READERS LOVE THEIR HORROR TATTOOS

DAVE DENT

Who did it? Allan Lowther at North Side Tattooz, Whitley Bay, UK.
What is it? *The Devil's Rejects* portraits.
Why did you choose it?
After meeting Sid Haig (Captain Spaulding) from the movie I extended my horror arm. I also have Freddy Krueger, Jason Voorhees and *Hellraiser*'s Pinhead.

DAVE GRAYSON

Who did it?
Myth at Indigo Tattoo, Northwich, UK.
What is it? The bloody face of a sexy female vampire.
Why did you choose it? I didn't. Myth wanted to do it and I had some spare space, so I volunteered.
How do you feel about it now? It's beautiful.

NIKIY AKA ROCKSTAR
Who did it?
Josh Webster at Top Shelf Tattoo, Belleville, USA.
What is it? A zombie chick.
Why did you choose it?
Because I'm starting a zombie collection.
How do you feel about it now? I love it.

ANDREW ELLIOT
Who did it?
Sean at Independent Tattoos, Wrexham, UK.
Why did you choose it? I just love the design.
How do you feel about it now?
I love it, and I think it's totally amazing. It took three hours to complete the work, but it was worth it. ➡

TERRY HAWKINS
Who did it?
Carl Collinson at Urban Image, Dorset, UK.
Why did you choose it? I love horror films and wanted to get a tattoo on my hand to prove my dedication. I already have my right arm sleeved, my left arm started, and tattoos on my legs and neck – all horror-themed.

JOBY

Who did it?
Gary Harper at Dream Warrior Tattoos, Barnsley, UK.
Why did you choose it?
You can tell I like horror films! The whole tattoo took 16 hours, but it was well worth it. It's a real eye opener and I get a lot of stares and good comments.

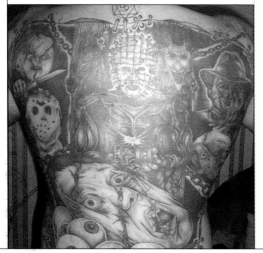

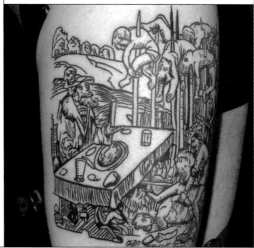

DAN HAYNES

Who did it? Ivan Henderson at The Wizzard's Den, Ontario, Canada.
What is it? It's from a 1499 German pamphlet depicting some of Dracula's supposed atrocities, such as eating his victims.
Why did you choose it? I have a fascination with the occult, the Dracula legend and folklore.

MARK BEAL

Who did it? Marc at Danny's Tattoo Studio, Nottingham, UK.
Why did you choose it? I love horror films, and it's the start of what will eventually become a sleeve of my favourite characters.
How do you feel about it now? It's quality, and I can't wait until I get more coin to get more done.

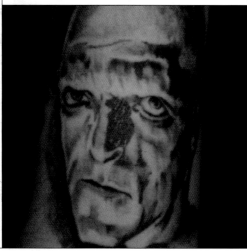

ANDY TRAGIC

Who did it?
Ade at Temple Tatu, Brighton, UK.
What is it? It's from *Shaun Of The Dead*.
Why did you choose it? Because *Shaun Of The Dead* is a film about friends as well as zombies.
How do you feel about it now? I usually get a good reaction, which makes me happy.

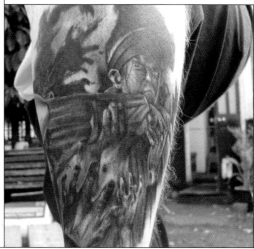

JAY DOWNS

Who did it? Eric Poland at Electric Eye Tattoo, Oklahoma, USA.
What is it? Serial killers John Wayne Gacy, Carl Panzram and HH Holmes.
What next? I plan on getting a koi fish body with Albert Fish's face in the near future, and possibly Ian Brady and Myra Hindley portraits.

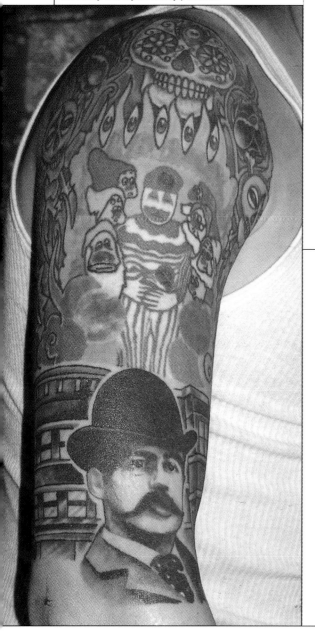

LES GEARING

Who did it? Csaba at Magic Moon, Erkelenz, Germany.
What is it? Demons.
Why did you choose it?
To make people think, "Why?"
How do you feel about it now?
It's awesome and I can't wait to get more.

MICHAEL LOZA

Who did it? Someone at Fine Lines Tattoos, Mesquite, USA.
What is it? An oozing zombie face.
Why did you choose it? Because I love Bob Tyrell's designs, plus it's ugly and creepy.
How do you feel about it now?
It's about four or five years old and I still love it. Ⓑ

Sexy BACK

THE CURVES, THE GASPING BREATHS, THE CONSTRICTION: WHAT COULD BE SEXIER THAN A FLESH CORSET?

PICTURES **JOE PLIMMER**

"That is the image of Satan!" screamed the preacher, pointing at an 18-year-old girl. "This is the image of the Devil!" And what had Allison, the girl in question, done to provoke such a strong and damning reaction? She was walking across her school's grounds wearing a backless top that showed off her 20-piece corset piercing, double laced with two strips of different coloured ribbon.

A corset piercing consists of vertical rows of surface piercings (which only go through one layer of the skin) on a person's back, which can be laced together to mimic an old-fashioned fabric corset. Eight to 12 piercings with 1.6-2mm rings is standard, but any number can be used, as in Allison's case. The corset is usually done as a temporary 'play' piercing that will only be in place for a couple of hours, and medical needles or rings are used to pierce the skin and house the ribbon that laces the flesh together. Permanent corsets are rare because of the problems associated with surface piercings, where the body will try – and usually succeed – to reject anything inserted into the holes. Having any kind of permanent jewellery in the back, either rings or bars that rings can ➡

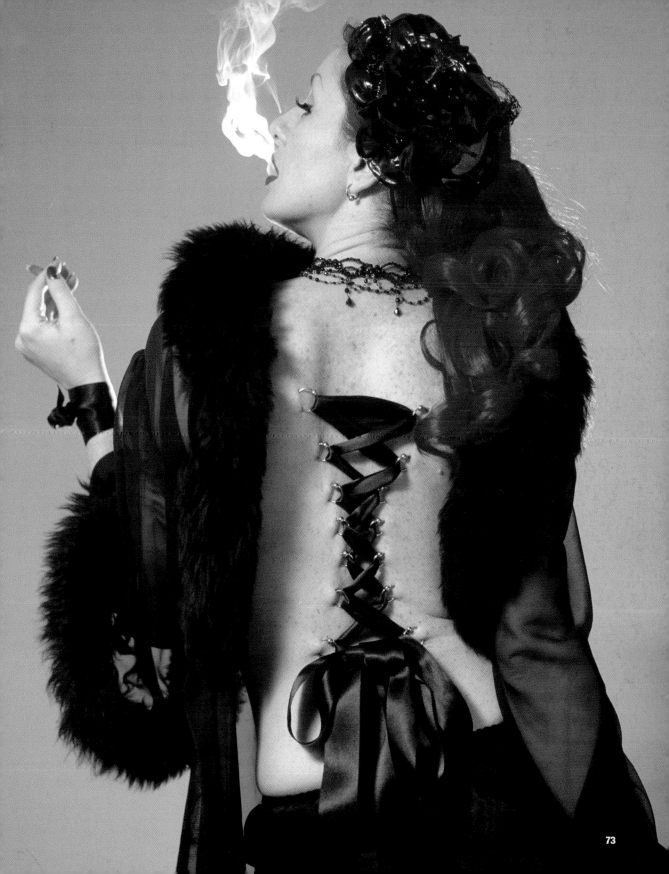

be attached to, also takes a lot of maintenance. Each piece of metal needs to be cleaned three times a day for a number of weeks and, given the position on the body, the corset wearer will need the help of someone dedicated.

To make things more difficult, permanent piercings can be extremely uncomfortable when sleeping, sitting on a chair, or even driving. So leading a normal life with this kind of body jewellery can be tricky. Whisper, a 24-year-old American, remembers: "While exercising on a resistance machine I lost concentration and got pushed up against the back board really hard and felt a sharp pain in my upper back. When I checked in the mirror I saw that the top-left ring had been pressed into my back, literally *into* the flesh, and all I could see was the ball sticking out. Yeah, that kinda hurt."

TATT FACT

Prisoners have been known to fashion primitive tattooing machines from guitar strings and the motor from a tape deck

Speaking from Indiana, Allison says: "Since my piercer Eric tied my corset kind of tightly, I had to sit up straight the entire day… we joked that it promoted great posture. I also couldn't lean back on chairs and had a little trouble expanding my arms. Plus the itching and not being able to get a hug was horrible!"

Some potential problems are less easy to anticipate. "My cat really enjoyed chasing after the dangling ribbons, so I was thankful he's de-clawed," says Whisper.

"MY CAT ENJOYED PLAYING WITH MY CORSET. I'M GLAD HE'S DE-CLAWED"

Grin and bear it: Lucifire relaxes during her corset piercing

Wearing clothes over the piercings can also add to the pressure and increase the likelihood of rejection or infection. Even if everything goes well, it can take up to nine months or longer to heal completely. Given all the complications, permanent corsets are rare and would not suit anyone who isn't experienced in dealing with piercings.

TUSK AND LUCIFIRE

For our photoshoot, body modification artist Dave Tusk (of Tusk Tattoo in Covent Garden and Tusktattoo.com, see page 20) performed a temporary corset piercing on fetish performer Lucifire. After a thorough clean of the area using pre-surgical skin scrub and alcohol swabs, the position of the piercings were marked on the skin, taking care to make sure they were symmetrical. The pair had decided on seven piercings, 3cm apart, on either side of Lucifire's spine. To accentuate the curves the markings were placed wider apart at the top, drawn closer together at the waist, and then flared out at the bottom to mimic the shape of a material corset. To add to this effect, the size of the rings used decreased towards the waist and increased again at the lowest piercings.

Dave used hollow piercing needles for this procedure as he prefers not to use the cannula-type needles used in most piercing studios. "They're not ideal," he says. "When pushed into the skin they concertina up inside and, as it's pushed through, it can be quite uncomfortable. The needles I've used require a little more skill, but are worth it in the end." Once the rings were in place, three metres of black ribbon were used to complete the look. ➡

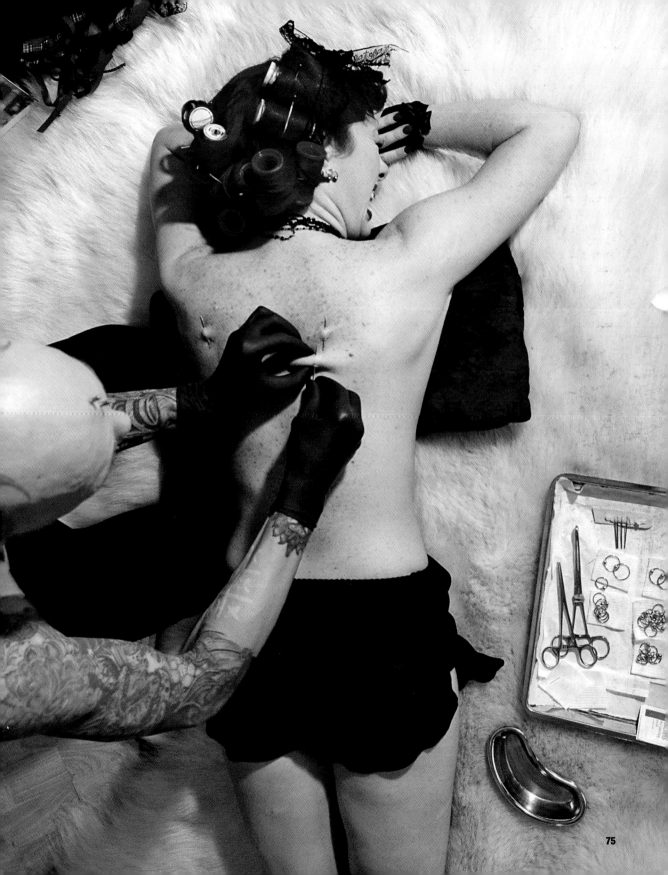

Lucifire, who performs a regular body suspension act, is no stranger to pain. "This is the first time I've had my lower back pierced," she says. "On my scale of one to 10, the actual piercing only rated about a three. It feels like someone pinching you hard, and then there's a tingling sensation."

But as Dave points out, the experience of pain is subjective: "There are so many different factors to your pain threshold. If you're feeling tired or even if a lady is menstruating, it'll create a different experience each time and you'll respond differently."

Allison's piercer, Eric, changed the placing of the final row of piercings on her back because he

"PIERCINGS ARE SO COMMON NOW. THIS TAKES IT TO THE NEXT LEVEL"

thought it would be painful. She says, "The lower you go on your back, the less skin is available to pierce and hold the rings 'comfortably'. It's kind of like comparing piercing your navel to piercing the back of your knee – your knee is going to hurt a lot more because of the lack of skin."

EXTREME REACTIONS

Although few people would react as extremely as the vicar who judged Allison's corset piercing to be the work of the Devil, even among the body modification community this kind of body art prompts extreme reactions, ranging from "now I know what love means" and "the most beautiful thing I've ever seen", to "I like piercings and I like corsets, but this is a very disturbing mix of the two" and "that's disgusting! I love piercings so much, but this is just taking it too far!"

But provoking horror and admiration is exactly the point for some fans of the procedure. "It's becoming harder to get extreme and opposed reactions," says Stephen Wilkinson of In Skin Limited, a body art studio in Tunbridge Wells, UK.

"Anything which is unfamiliar is rejected instinctively by most people. We're so acclimatised to piercings now, you don't get that visceral reaction until someone takes it to the next level. That could be why corset piercing has started to become more popular now – for that small percentage of people who want to get that kind of strong, visceral reaction, they're going to have to do something fairly severe these days." ➡

Don't try this at home! Dave Tusk knows what he's doing...

TATT FACT

Thomas Edison, creator of the first practical lightbulb amongst other things, invented the technology for tattoo machines, which he used to make stencils for printing

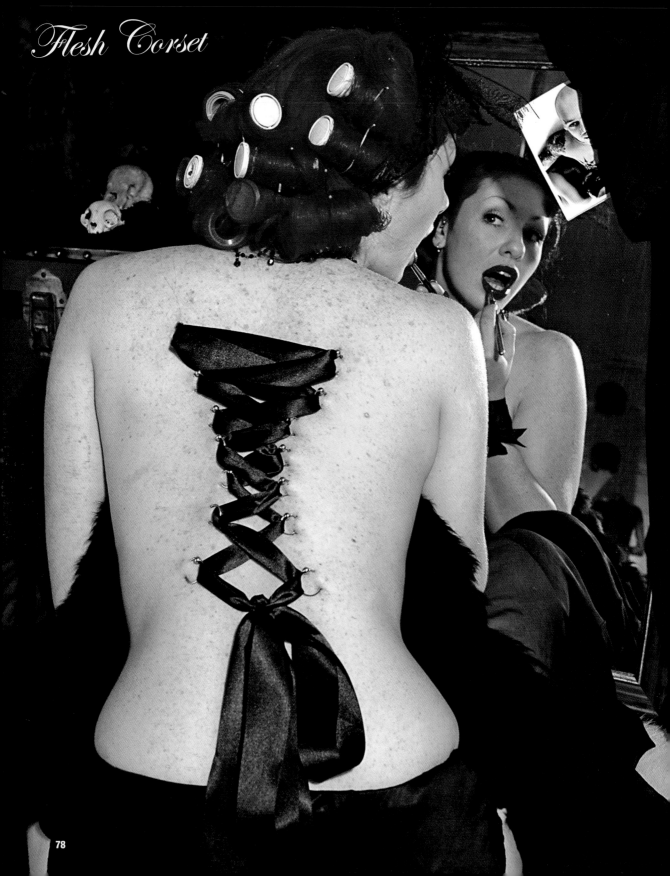

Flesh Corset

Proving Stephen's point, one fan says she was motivated by "the shock value", while another credits the desire to "cause a bit of a ruckus" at a formal dance as her reason for combining a backless dress with a corset piercing. Although that's not the whole picture, certainly no-one does this thinking it looks ugly. The eroticism of the traditional corset was championed by the Victorians and lives on in the world of new burlesque and Mr Pearl, the famous fetishist who's reduced his waist to just 18 inches. For fans of piercing it's erotic and sexy in the extreme. As one admirer puts it,

"SEX WITH THE FLESH CORSET WAS FUN. I DIDN'T NEED TO DRESS SEXY"

"Here's a beauty you cannot get from clothes." Whisper also enjoyed the heightened sensuality of having her piercing: "Sex with the corset in was fun. No real need to wear anything else sexy, it was already there. It was the ultimate accessory."

While you might not think it to look at a corset piercing, and despite the complications of maintaining it, some people believe it has the potential to become more mainstream. Stephen Wilkinson says, "We've been designing different types of jewellery, different methods of piercing and new aftercare products, which means that we can now do surface piercings with more success. If that comes to fruition and we can do surface piercings anywhere on the body with a 90 per cent success rate, then you'll see more of this kind of thing." And that would mean a lot more devil children on the streets to scare the religious and uninitiated. ⑬

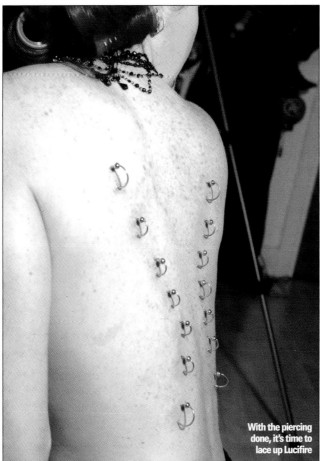

With the piercing done, it's time to lace up Lucifire

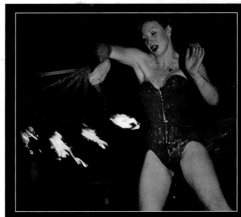

MEET LUCIFIRE
WHO'S OUR BRAVE FLESH CORSET MODEL?

Extreme fire performer, singer, choreographer, compère, freakshow artist, underground icon and the most extreme female suspension act in the world, Lucifire is our kinda girl.

Lucifire has performed at many prestigious events including the Glastonbury festival, *Metal Hammer* Awards, and the Lord Mayor of London's Thames Festival, where she sang with a 22-piece swing band, The London Swingfonia.

Fans of the burlesque scene will doubtless have seen Lucifire performing with Dave Tusk as part of the Fire-Tusk Pain Proof Circus, and if you want to know more, check out Myspace.com/lucifire and Lucifire.com.

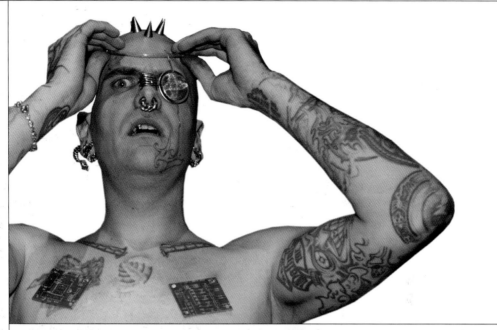

SAMPPA VON CYBORG

HE'S GOT A METAL MOHAWK, TATTOOS ALL OVER THE PLACE AND SUBDERMAL IMPLANTS IN HIS COCK. MEET SAMPPA VON CYBORG, THE WORLD'S PREMIER BODY MOD EXPERT

WORDS **DAVID MCCOMB** PHOTOS **ASHLEY/SAVAGESKIN.CO.UK**

amppa Von Cyborg is one of the biggest and most respected names in body modification today.

The Finnish artist – whose metal Mohawk, facial tattoos and countless piercings have appeared in many high-profile advertising campaigns, including spots for 888.com and Snickers – is the owner of MadMax Tattoo & Piercing in Tampere, Finland, a studio famous for developing some of the most striking and ambitious surgical modifications in recent years. Amongst his most notable creations are Flesh Stapling – where bars of metal are hooked into a person's skin, in a similar style to paper staples – and Surface Weaving, which sees jewellery passing in and out of the wearer's skin, a piercing commonly known as a MaxMax Bar in homage to Samppa's studio.

Now living in London, UK, Samppa is also founder of the modern-day freakshow performance group Psycho Circus, creator of the Cyber Cell Collection range of jewellery, and director of a series of underground movies, including the surreal short *Scabs* and the upcoming *Alice D*, a full-length feature with contributions from the world's most famous body modifiers and tattoo artists, including Lukas Zpira, Dave Tusk, Lucifire, Space Cowboy, Maleficent Martini and Crazy White Sean, along with other big names such as Ginger of The Wildhearts and Megan Burns aka Betty Curse.

How did you first get interested in tattoos and body modification?
It all started when I was 10 years old. I was in Copenhagen with my parents and, because tattoos ➡

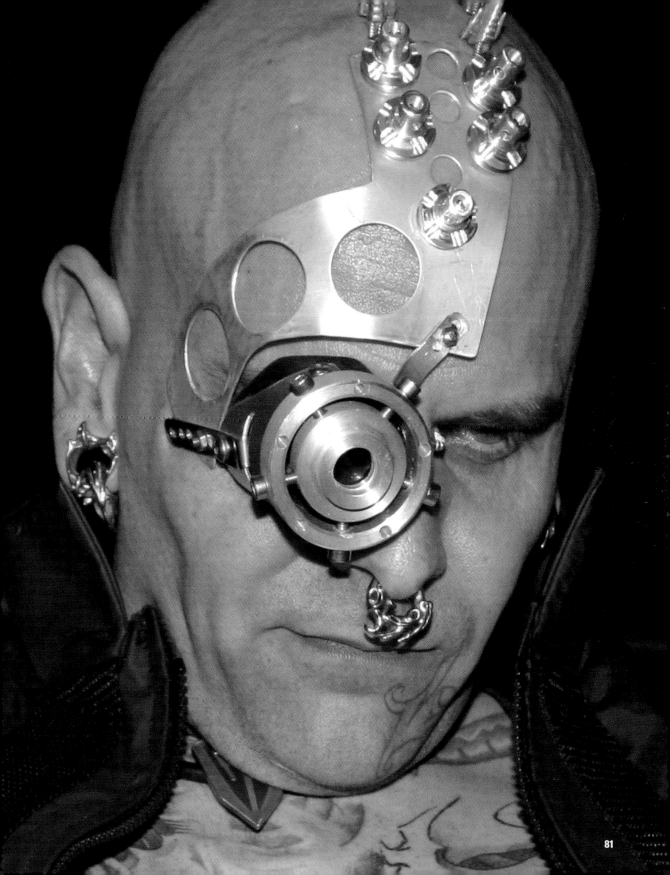

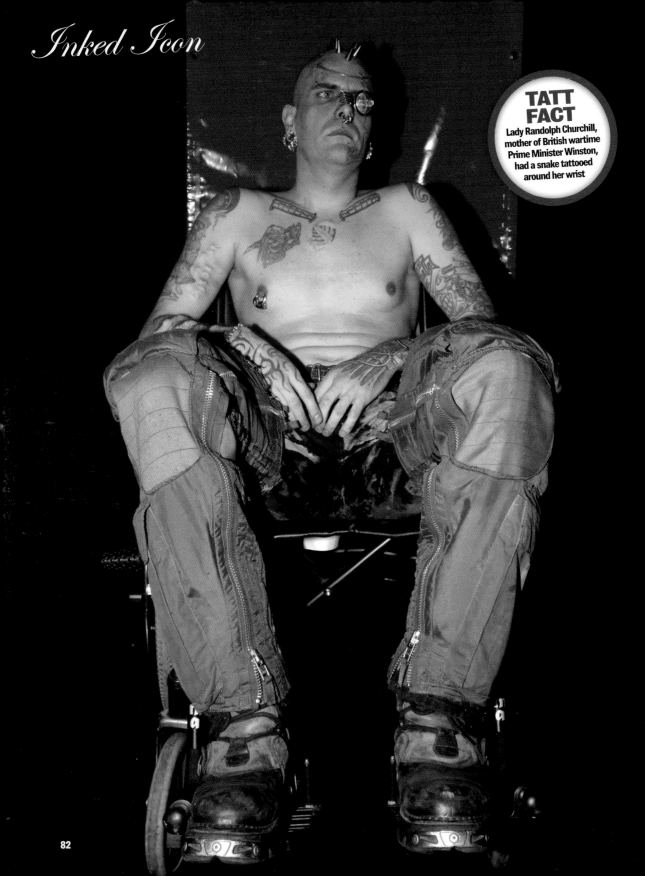

TATT FACT
Lady Randolph Churchill, mother of British wartime Prime Minister Winston, had a snake tattooed around her wrist

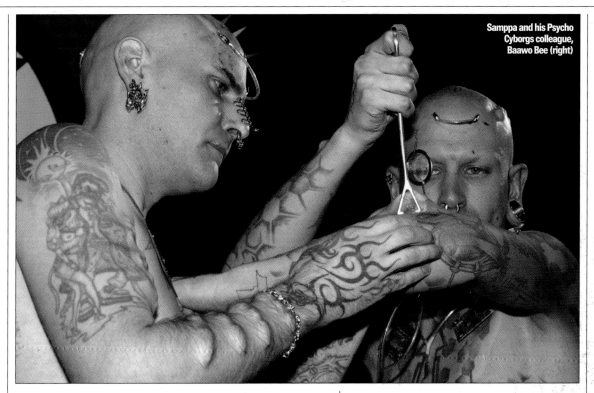

Samppa and his Psycho Cyborgs colleague, Baawo Bee (right)

"I'D LIKE VIBRATING IMPLANTS IN MY COCK, BUT I'LL HAVE TO DEVELOP THEM"

weren't common in Finland in those days, it was the first time I'd ever seen pictures on someone's flesh. My father explained what tattoos were, and from that moment I wanted one. Obviously I was too young to get any work done, but by the time I was 12 I'd found out how to do tattoos and was experimenting on my skin using safety pins and ink. Around that time I also got interested in piercing, and when I was 13 I used my brother as a guinea pig and pierced his earlobes – which, of course, meant we ended up in a huge fight with our mother and she made my brother take the piercing out. At 15 I got my nostril pierced, and on the day of my 18th birthday I made an appointment to get my first tattoo.

How did you make your fascination into a career?
A Finnish tattoo artist taught me how to do piercings and, although it wasn't something I was particularly interested in, it was still a good opportunity as it allowed me to work in tattoo studios and meet similar people. When I started work in 1990, piercings weren't very mainstream or popular. Then, in the space of a year, everybody wanted to get them. And as I was one of the first body piercers in Finland there wasn't much competition and I had a *lot* of work, sometimes 30-40 piercings a day. So I just worked at getting better and developing new techniques, and I kept a diary where I recorded my tests using different needles and so on. But after 10 years of piercing eyebrows, lips and navels every fucking day, I got bored and had a sort of burnout. That's when I knew I had to do something new.

How did you go from piercing to body modification?
At first I wasn't into body modification. I remember seeing the RE/Search book *Modern Primitives* for the first time, and I couldn't really understand why people wanted to get that sort of shit. But then I saw Steve Haworth's work – metal Mohawks, subdermal implants and so on – and it totally changed my world, and I knew what I wanted to do with my life. At that time there weren't any artists in Europe doing that sort of work, and I realised that I'd either have to go to the States or start doing procedures myself.

How did you learn to do body mods?
One of my tattoo clients was a doctor – an ear, nose and throat specialist. He was interested in body modification as well, and he said he'd teach me how to do the ➡

work. Of course, I jumped at the opportunity. He taught me how to do all those surgical procedures, such as using a scalpel to go under the skin and so on. Aside from Steve Haworth and Lukas Zpira, I was the only person doing work like this, and it wasn't long before I'd made a name for myself. And because I'd been taught by a doctor, I really knew what I was doing.

Then you started developing your own techniques…
It was around 2001 when I got my big break, when I came up with Surface Weaving which, of course, is now known as MadMax Bars. Then I developed Flesh Stapling, which has also become famous. That's how I made a name for myself – in the 21st century, almost everything's been done and it's rare to find anything unique. If you do, you soon have a reputation.

Are there legal issues to consider when doing body modifications?
There aren't any laws in Finland about body modification, and it's much the same everywhere in Europe. But in the United States it's different – you can get in serious legal problems. But over here body modification is at such an early stage of evolution they don't really have any laws. Body modification is legal using a scalpel and similar tools, so long as you call it 'body art'. If you mention the words 'surgery' or 'plastic surgery', then people could claim you're doing surgery without a licence, which is illegal. The other thing I can't do is use an anaesthetic – you need a licence for that. Personally, I'd like it if people had to study for a number of years to become a body modification artist, much like a doctor.

What body modification work have you had done?
I have quite a few tattoos. Then I have a metal Mohawk – the spikes can be screwed into 15 implants in my head – along with a split tongue, subdermal implants in my arm and chest, and transdermals in my wrist. I also have some subdermals in my cock, and a big Prince Albert, a pierced nipple and pierced septum. Aside from that, I don't have many piercings. I also have metal teeth, and the latest thing I had is a half-face tattoo in UV ink [see page 154 for more on UV tatts].

That's quite a lot…
Compared to some people, I don't have that much. I do have some extreme body modifications, but at the same time I want them to be stylish – if you have too many, it's too much. For me, it's more effective if you only have a few, more extreme things. I have a good sense of style, and anything I get done has to fit with this.

How do people react when they see you?
To be honest, I don't notice any more. It could be a way to protect yourself, but I don't pay attention to people. When I'm with friends I don't see often, they notice how other people look and point at me, but I'm not even

aware of this. When I first moved to London I got noticed all the time, and people would come up to me and ask the same questions: "Are those spikes stuck in your head? Does it hurt?" People's reaction is that they're genuinely interested, and I never get negative feedback. And I think that's because I don't have too much work and it looks good – if my face was full of piercings, it might be different.

When you started to get work done, how did your family react?
I still remember, around 20 years ago, my mother asking me when I'd get a real job. I told her I had a proper career, but she was convinced it was just a passing fashion. But now my father runs my studio in Finland, and basically it's a family business. He doesn't actually do any of the work, but he's the manager of

"I'M DESIGNING A BIOMECHANICAL ROBO-DICK DILDO AT THE MOMENT"

MadMax. My parents are quite open-minded nowadays. I mean, my mother doesn't like my metal Mohawk, but she does like my back tattoo, and now she's too tired to fight me any more. Recently she called me when I was in Poland, and asked what I was doing there. I told her I was there to get my teeth fixed, but there was silence on the other end of the line when I told her I was there to get metal teeth. Then she went mad! But, as far as I'm concerned, I don't have to consider other people when I get work done on my teeth – it's my fucking mouth.

Is there any more work you'd like to get done?
These days I'm working on functional implants. I'd like vibrating implants in my cock – but these things don't exist, and so I'll have to develop them myself. There are still some tattoos I'd like – not many, but a few.

Aside from your movie making, what is next for Samppa Von Cyborg?
I also make jewellery, and I'm planning to start a proper wholesale business – making quality body jewellery from stainless steel. I'm also working on a dildo project; I'm making a kind of robo-dick which I hope will go into production at the end of this year. It will be in a biomechanical style, the sort of cyber, HR Giger-inspired designs I like. I also do illustrations, CD covers and stuff. I designed Ginger's Howling Willie Cunt album artwork. The latest album cover I did was for Interlock.

Finally, I've got to ask, what is the most painful piece of work you've had done?
That question is painful! Ⓑ

With the Psycho Cyborgs, Samppa has fused the worlds of performance art and body modification

MUSIC

WHAT BETTER WAY TO PROVE YOUR DEVOTION TO YOUR FAVOURITE BAND? FOR TRUE FANS ONLY

JAMES SMITH

Who did it? Claudia at Frith Street Tattoo, Soho, London, UK.
Why did you choose it? It was taken from my favourite song, 'Paint It Black' by the Rolling Stones.
How do you feel about it now? Pretty stoked. I've wanted it for the last four years.

KRISTIN

Who did it? Christy Brooker at Apocalypse Tattoo: Seattle, USA.
Why did you choose it? Because Michael Jackson was my favourite musician as a child. (It's his shoes, if you can't tell.)
How do you feel about it now? It's funny, and people tend to like it a lot for some reason.

ALISON LEESE

Who did it? Rich Warbo at Rich Inks, Stoke-on-Trent, UK.

Why did you choose it?
Out of respect to guitarist Dimebag Darrell Abbott, who was shot onstage in 2004.

How do you feel about it now?
I love it. I couldn't have pictured it looking any better!

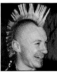

GLEN CYTHON

Who did it?
Odge at some tattoo shop that's closed down now in Camden Town, London, UK. I can't remember the name – sorry!

What is it? PUNX on my lip.

Why did you choose it? Because I'm a punx!

How do you feel about it now? I love it!

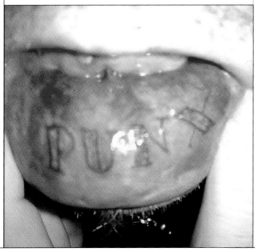

CLEMENTINE

Who did it? Michael Le Brock at Inklined Tattoos, North Walsham, UK.

What is it? My favourite band of all time, KISS! It's of all four original members.

Why did you choose it? KISS are fucking awesome.

How do you feel about it now? Very chuffed. I can't wait to get the finishing touches put in. ➡️

KATRINNA SEWELL

Who did it?
Nick at Diamond Jacks, Soho, London, UK.
What is it?
A butterfly/angel/Björk-type thing.
Why did you choose it? It was some Björk fan art.
How do you feel about it now?
I still love it and want more.

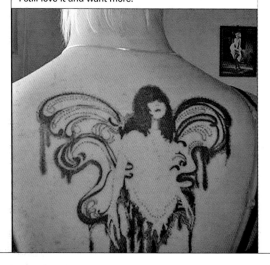

JAMES OLLIS

Who did it? Ray Hunt at Medway
Tattoo & Piercing Centre, Rochester, UK.
What is it?
It's a record sleeve by a band called
Dukes Of Nothing. I was at a point in my life where
I decided I needed a really fucked-up tattoo.
How do you feel about it now? Pleased as punch.

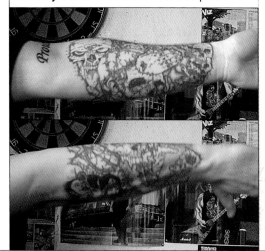

KERRY GILBERT

Who did it?
Ben Hammil, Bournemouth, UK.
What is it? An angel at the bottom
of my back, with Amen lyrics at the top.
Why did you choose it?
It was based on a dream I had.
How do you feel about it now? I still love it.

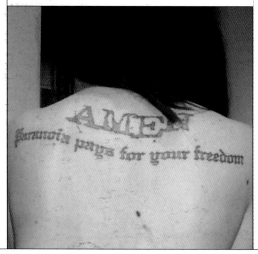

HOLLY

Who did it? Lee Hooper, in my kitchen in
Swindon, UK.
What is it? Dimebag tribute artwork.
Why did you choose it? Dimebag
was the best musician to ever grace this Earth.
How do you feel about it now?
It's probably my favourite tattoo.

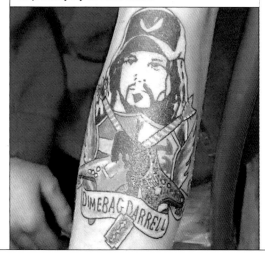

ROODLE

Who did it? Mark Goddard at Fantasy Fine Line, Maidenhead, UK.

What is it? The top is a dedication to my favourite band, My Ruin. 'Absolution' is my favourite song by them, and it's also a tribute to all those people who've forgiven me and the stupid mistakes I've made.

ALEX BARTEL

Who did it? Chanslor at Wildcard Studios, Wilmington, USA.

Why did you choose it? Music = Life. I love the Deftones.

How do you feel about it now? It represents my love of music and creativity. A nice way to start my full sleeve.

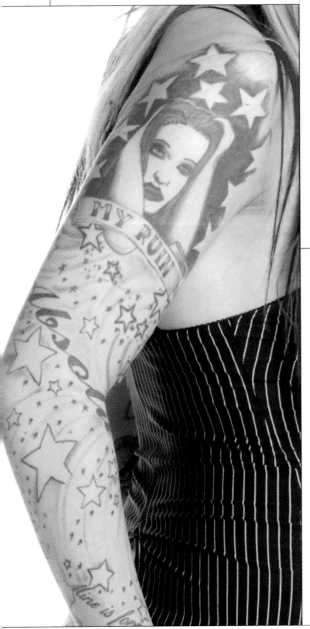

STEPHEN CROSSLEY

Who did it? Saz at Saz's Tattoo Studio, Warrington, UK.

What is it? 2 Tone Records' Walt Jabsco.

Why did you choose it? I like the music, and thought it was a really distinctive design.

How do you feel about it now? I love it – it's my favourite tattoo. ⑬

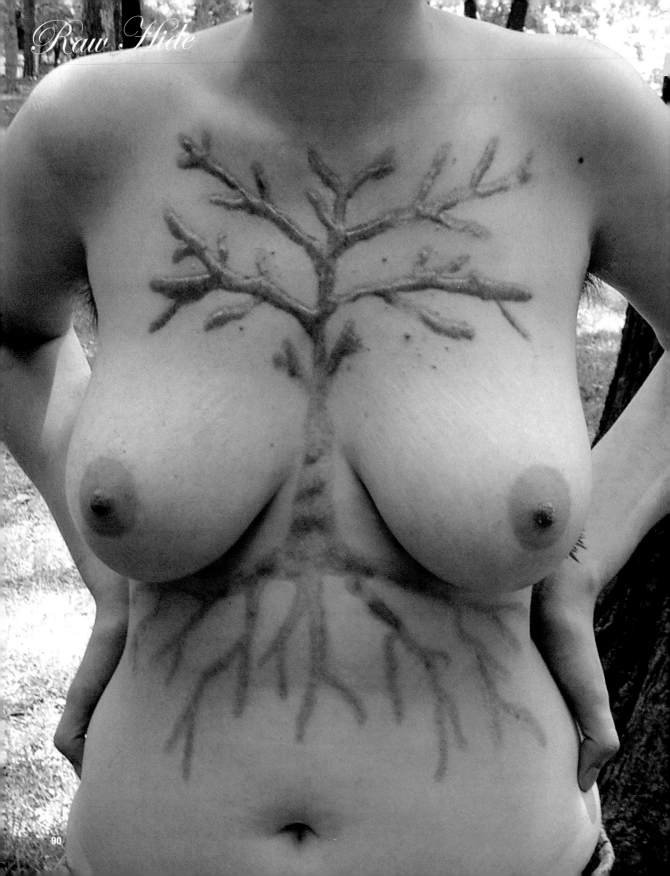

FEEL THE BURN

SEARING PATTERNS INTO LIVING FLESH ISN'T JUST FOR CATTLE AND CRIMINALS. *BIZARRE* SETS THE TEMPERATURE TO 1,000°F AND DELVES INTO THE BRANDING SCENE

WORDS **JAMES DOORNE** PHOTOS **BYBLAIR.COM**

Branding has an image problem. Over time it's gained a reputation as the body modification most likely to be performed by drunken idiots on their drunken friends, and many people's branding frame of reference begins and ends with cattle, slaves and lawbreakers being marked as a symbol of ownership or criminality. What's more, almost everyone thinks it's done with a branding iron heated in an open fire and stamped onto your skin.

But people have the wrong idea. Branding can be beautiful, and it can be intricate. The days of white-hot irons, crude and shapeless scars, and an almost unbearable amount of pain are long gone, and branding techniques have come a long way.

Although strike branding – applying heated metal to another person's skin – is still practised, it's nothing like branding a cow. These days, most branding practitioners use specially-designed cautery 'pens' – pencil-like implements with a red-hot element that's used to burn the skin – or electrocautery devices, that use electricity to burn the skin rather than applied heat. There's even cold branding using liquid nitrogen.

MODERN BRANDING

By far the most interesting form is strike branding, where heated metal is used to burn a design onto a person's skin. And one man changed the practice from largely unpredictable and boring into a versatile, precise and respected art form.

Blair, a body modification artist from Toronto with nearly 15 years branding experience, invented multiple-strike branding where, rather than ➡

a single branding iron being pressed onto the skin or several standard shapes being used collectively to make a single design, a small piece of metal is heated and applied to the skin over and over again until the design is complete. Body modification almighty and Bmezine.com founder Shannon Larratt describes Blair as having "pushed traditional strike branding to the limits of the art form".

"Without knowing it, I changed the entire technique and how people brand these days," says Blair. "With my technique you can virtually do anything because it's just applying heat in a controlled way; you heat up the metal and apply it just like a paintbrush."

Back when Blair started out, strike brandings were done with a variety of standard shapes used in conjunction with each other to create as close to the desired effect as possible. "Fourteen years ago, branding was literally strike branding of little dots, curves and lines, and that was it," he says. "People used eight different shapes and would try to make everything out of those shapes. They'd heat up the curved iron, then heat the curved one again to make a circle. But you can only do so many designs like that, and it became really limiting. All my friends were walking around with stuff that was pretty damn similar." So in an attempt to create more intricate pieces, Blair created multiple-strike branding.

For multiple-strike branding you need a single piece of surgical stainless steel about a quarter of an inch in length that's held with vice grips, heated using a propane blowtorch, and pressed onto the skin. The piece of metal is reheated as necessary to ensure it's hot enough to continue.

"You have to heat the steel for between 30 seconds and a minute for it to go red-hot," Blair says. "When the steel heats up it turns a particular colour that indicates it's hot enough to use. I used to work with silver, but when you heat silver it looks much the same, like it's not really hot enough. When silver gets *really* hot it gets this whiteness to it, but when you heat surgical steel it literally goes from metal colour to neon red, so you can easily tell it's hot enough. I don't know exactly how hot it is – I think it's about 1,025°F – but it's just about as hot as you can get it."

"MODERN BRANDING IS LIKE PAINTING ON A PERSON'S SKIN WITH HOT METAL"

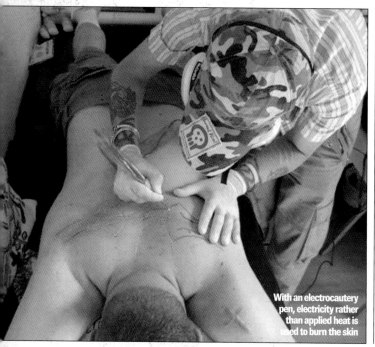

With an electrocautery pen, electricity rather than applied heat is used to burn the skin

"My work is just like painting, and that's really what I'm doing. I'm painting on the skin with hot metal. I keep applying the heat and paint a little, then I apply the heat and paint a little more. It's a totally different process to traditional strike branding. Basically, it eliminates the chances of any mistakes happening."

SINGLE-STRIKE BRANDING

The control that Blair has is something that could never be said about single-strike branding, the technique that most people are familiar with. That requires a branding iron… and a lot of luck.

"I've never done single-strike branding because it doesn't make a lot of sense to me," says Blair. "I've seen it done, and it's not a good technique because all the skin on the human body is curved. If you look at your bicep, for example, it has a subtle curve, so if you use a traditional flat branding iron – even if it looks pretty, and I've seen branding irons that were really well-made – it's a risky thing to do. There's no way a large branding iron is going to make an even scar; it's just not logistically possible.

According to the owner of these knuckles, the branding was no more painful than the tattoo

This pic: The immediate aftermath of a branding
Right: How the scar eventually heals

"If you want a huge circle on your back with a 12-inch diameter, then you'll need a huge 12-inch circle strike-branding iron. But if I use one little tool just a quarter of an inch in length, I can apply that iron again and again around the entire body. And I can do the whole thing consistently. Using multiple-strike branding, each section of the design will have been hit evenly, which you can't guarantee from a normal strike branding."

And that's important. Blair estimates that when working with human skin, you're working to "within a millimetre". "If you heat a traditional branding iron, you're less likely to heat the whole thing up evenly. And when you apply it to the skin, if you're a millimetre too deep in one place and a millimetre too shallow in another spot, the whole design is going to turn out dodgy. It's important that the branding is as consistent as possible," he says.

You also need to know how the skin is going to react. Everyone's skin is different and reacts in various ways to being branded, so it helps to try out a small piece to see what happens.

"The timing and amount of pressure that I apply to the skin can vary considerably from person to person," he says. "I could brand one person and hold it down for literally less than a second, but with another person who has thicker

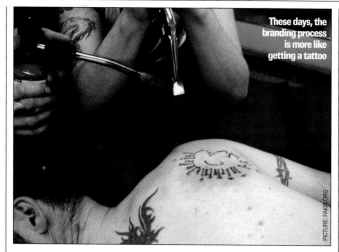

These days, the branding process is more like getting a tattoo

PICTURE: FAKIR.ORG

"I'VE SEEN SOME US FRATERNITY COLLEGE BRANDING. IT'S HORRIBLE"

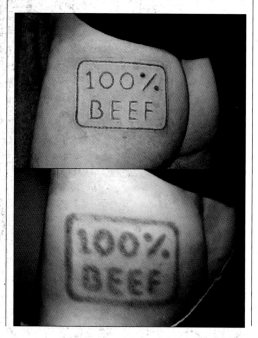

During the branding process the smell can be grim. Some people say it stinks like "burning hair", while others compare the smell to "cooking bacon"

skin I could brand their wrist for a full second and a bit, or possibly even longer.

"What I end up doing is to pinch the skin first to get an idea about the area that I'm going to be working with. Then when I apply the first strike, because it's done in little increments, I'll just do a little strike to see how the person's skin burns. Some people's flesh burns really easily and it's soft like butter, but other people's is more like leather. My first strike gives me a pretty good understanding of how the skin is going to burn. And from there, when I burn the second, third and fourth strike and so on, I have a good idea of what's going on and how to get a consistent temperature and a consistent depth for that person's skin.

"A tattooist will tell you that some people's flesh is really leathery, and it could take 15 or 20 minutes to get the ink into that person's skin, whereas with the next person the ink goes in really easily and you can have the whole tattoo done in five minutes. And that's purely dictated by the type of skin your client has.

But even when the skin is "leathery", don't think the process will be simple like branding a cow. "Cattle are essentially a big side of beef, so it's flatter and the skin is thick," Blair says. "So if the guy 'overbrands' or 'underbrands' ➡

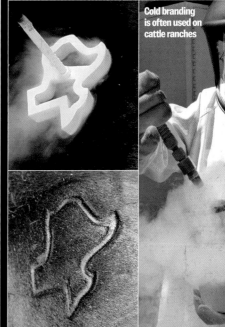
Cold branding is often used on cattle ranches

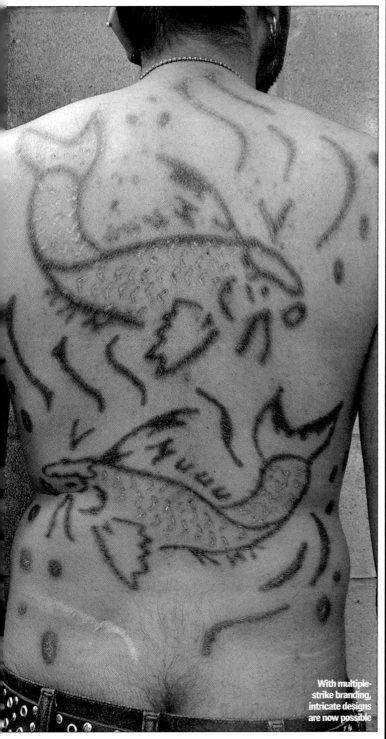
With multiple-strike branding, intricate designs are now possible

TYPES OF BRANDING

THERE'S MORE THAN ONE WAY TO BRAND A COW – OR A HUMAN BEING, FOR THAT MATTER

CAUTERY BRANDING is where a pen-like implement with a hot piece of metal where the nib should be is dragged across the skin, burning as it goes. A lot of people say it's the most painful type of branding. **ELECTROCAUTERY BRANDING** is slightly different. A similar implement is used but, rather than using applied heat to burn the skin, it uses electricity. No part of the equipment actually touches the skin at any point. Electrocautery and cautery branding are the most efficient methods to use for larger designs – this is because they're quicker as there's no reheating time like there is with **STRIKE BRANDING**, which is when hot metal is pressed onto the skin. You should avoid single-strike branding using a branding iron – the multiple-strike branding method created by Blair is safer, and a much better bet for even heat distribution and consequently a half-decent design. **COLD BRANDING (or FREEZE BRANDING)** also exists, but is rarely, if ever, used on humans. The metal is cooled using liquid nitrogen (or sometimes a five per cent dry ice/95 per cent pure alcohol solution) before it's applied to the body. As well as being expensive, it doesn't yield good results.

This pic and below: Pig meat is ideal for practising branding, due to its similarity to human flesh

Branding combined with tattoos makes for a striking look

TATT FACT

Tom Leppard from the Isle of Skye has a leopard-skin tattoo covering 99.9 per cent of his body. Only the inside of his ears and between his toes remain tattoo-free

then it doesn't matter. They're just concerned about leaving a mark, whereas we're concerned about creating a perfect design. If I had to brand a large circle on a person and they moved even a millimetre – which is pretty likely with a hot poker coming at you – then the chances of having it turn out as a perfect circle are low."

BRANDING AND PAIN

Although Blair says he brands more women than men, in the US it's a big, macho deal to get branded. So much so that George W Bush's old college fraternity, Delta Kappa Epsilon, have been known to brand new recruits with a half-inch Greek letter Delta in the small of their back.

"I've had customers who've used a coat hanger bent into the shape they wanted," Blair says. "I've seen the results of fraternity branding and it's horrible. I've had some people bring a branding iron to show me what they use, and the chances of it ever being successful are minimal. But I think people are opting out of getting their drunken buddy to brand them, and would rather have it done by a professional where there's no room for error. I've seen so many people who did stuff on themselves then really wished they'd gone to see a professional.

"For example, if you want to get your initials branded you can look for a font you like with lots of special detail, and I can recreate those letters perfectly. But if you're doing it with a coat hanger, there's no way you can recreate that detail."

And Blair – who has a large branding scar that covers his forearm from wrist to elbow – promises that it doesn't hurt as much as you'd expect.

"It's different to burning yourself," he says. "People have a lot of misconceptions about this. Imagine 14 years ago, if you'd told someone that you were getting your tongue pierced, they'd have thought you were out of your mind. But nowadays kids are getting their tongues pierced all the time. And who would've thought it could come to that? People had the notion that tongue piercing had to be the worst pain ever. But when people finally got it, they realised it's not that bad at all."

One of the reasons that branding is less painful than expected is that your nerve endings are cauterised as you go. The pain comes and goes in an instant. The skin will be closed off for about a week until the cauterised flesh falls away and leaves an open wound. But that will heal like any other cut, and in about three

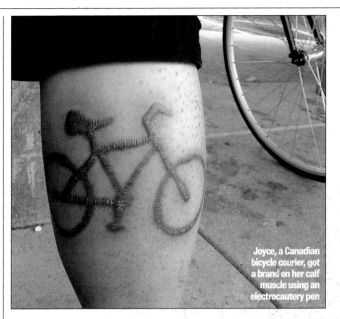

Joyce, a Canadian bicycle courier, got a brand on her calf muscle using an electrocautery pen

"BRANDING IS THE NEXT BIG THING IN BODY MODIFICATION AS IT'S ORGANIC"

weeks you'll have a bright pink scar that will eventually fade over time.

And Blair says the more people understand branding, the more want it done: "It's definitely getting more and more popular. I think it's the new big thing, because people already have tattoos and piercings, and they've done implants and things. Branding is the next big thing in body modification, mostly because it's completely organic. It doesn't involve any pigments being added to your skin. It doesn't involve anything being added to your body – it's literally just your own skin. It's more natural than a tattoo could ever be. And people love the idea that it's only their body. Even when I tell a customer that everybody scars differently, and that you can't guarantee it'll look like a guy they saw in the *National Geographic*, they're like, 'Oh, that's what I love about it! It's all determined by my body and it's unique.' I'm surprised people like that variety, but they do." Ⓑ

To see more of Blair's branding work, check out his website at Byblair.com

LINCOLN

IT'S NOT ONLY WOMEN WHO MODIFY THEIR BODIES WITH BREAST IMPLANTS. MEET THE MALE ATTORNEY WITH A DD-CUP

WORDS **JAMES DOORNE** PHOTOS **GARTH STAUNTON**

Unlike most people who undergo breast augmentation surgery, Lincoln is neither a woman nor in the process of becoming one. His implants, which he had done in 2003, are, he says, "an expression of a sensuality" that exists within him but wasn't mirrored in his natural physical appearance. His partner, Mike, also has implants, and they're both hoping to have future operations to increase their breast size.

What size are your breasts?

I have no idea what cup size they are, but they're 700CCs of silicone. It's definitely not a gender issue for me. Instead, it's a desire for sensuality inside my own body. My partner, Mike, has 600CC breast implants. We're both going back for more surgery in due course. Twice or three times the size is what I'm aiming for. The idea is to go *really* big.

When did you first realise you wanted breasts?

The first time I thought about breast implants was when I went to a plastic surgeon to sort out my stretched earlobes. While I was there I realised that I'd wanted breast implants for as long I could remember. There's some psychology that goes with it in terms of masculinity and femininity, as well as emotional supports and psychological underpinnings to the desire, which I do understand. It's not about feeling uncomfortable being male. Actually, I'm very comfortable being male.

Was it hard to convince a surgeon to perform the operation?

I managed to convince a surgeon that I wasn't a lunatic just wanting to do odd things, and that I was a rational person. I think the fact that it's a reversible procedure and that I'm a non-practising attorney was helpful. I told the surgeon I'd create and sign any kind of waiver he wanted, and he was fine with that. ➡

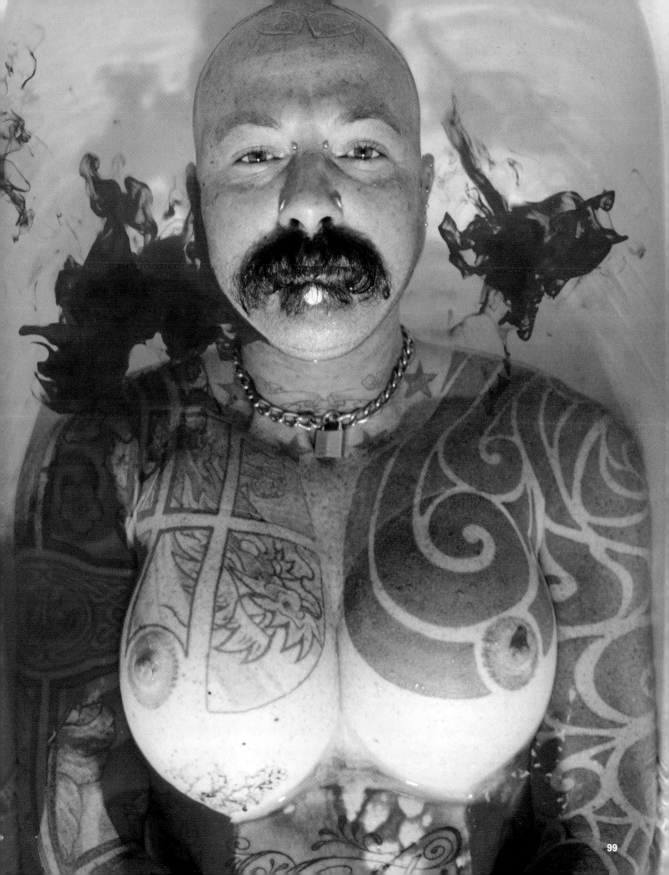

How did your friends and family react?

Some of my friends didn't bat an eyelid when I had it done. Others said, "Eurgh, how could you? Boys aren't supposed to have boobs!" My parents may know, but they haven't said anything so far. My sister just thinks I'm a loon. She's very happy, but she'd like me not to show too much to my parents because it'd be too much for them to deal with.

Has it affected your professional life?

It hasn't affected my work because my priorities have shifted. I couldn't practise as an attorney looking the way I do. I still draft contracts, but I don't think people would be too pleased to see me in court. I decided to move into the film industry where people really don't give a shit what you look like. I'm now lecturing, doing my PhD and consulting.

Is there a typical reaction to your breasts?

People respond in ways that I'd never expected. I get little old ladies coming up to me in shopping centres and saying, "Wow, that's amazing! That's brilliant!" And then I get cool, funky and interesting people looking at me as if I've just crawled out of a tube.

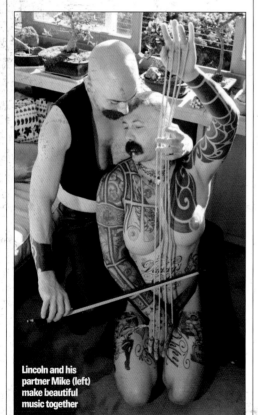

Lincoln and his partner Mike (left) make beautiful music together

Sexually it's been interesting because there's been a range of guys who've been interested in me – much more interested than they'd normally be – and there have also been guys who've been freaked out by my implants. I was in a bar once and there was this guy who spent the whole night telling me how awful he thought my implants were, but then ended up sucking my cock. It's not clear cut that certain groups of people hate my implants and certain groups love them. They push people's buttons in both good and bad ways.

When I was in Cape Town this big, butch, very straight north African guy came up to me when I was wearing a tight top and showing cleavage, and said he liked my style and that I have nice tits. I was surprised! I'm sure there would be more drastic reactions if I let the implants hang out in conservative places. But I'm not really in the mood to be beaten up, so I generally tend to downplay them if I'm in a dodgy area.

Did the implants take a lot of coming to terms with?

When I first got them, I had to come to terms with the fact that the world was going to see me in ways that I didn't necessarily want to be seen, and that I was

"LITTLE OLD LADIES COME UP TO ME AND SAY, 'YOUR BREASTS ARE AMAZING!'"

going to be stared at a lot. At first I was very self-conscious about them and being seen out in public, and I'd wear big, baggy clothes. But inside, when I was on my own or with friends, it just felt so natural and comfortable. Slowly I became a lot less self-conscious about them, and now I'm not really perturbed about them in public. They just feel right.

What about the operation?

I was in bed for three days afterwards and in a lot of pain before I was able to move. It was a week or more before I could lift my arms. Psychologically, I became rather self-conscious for a couple of months. At the time I was seeing someone who wasn't interested in me having implants. He felt that he was gay because he didn't like women, and didn't want to be with someone who challenged that, and as a result I was self-conscious in relation to him. Mike, on the other hand, was sitting up the day after his operation and just fell into the psychological aspect of having boobs like a duck to water.

Could you have used hormones to grow breasts?

I considered using hormones to create my breasts but it didn't feel right. I've tried female hormones and it ➡

A tattooed man with breasts and horns sitting astride a fake sheep, yesterday

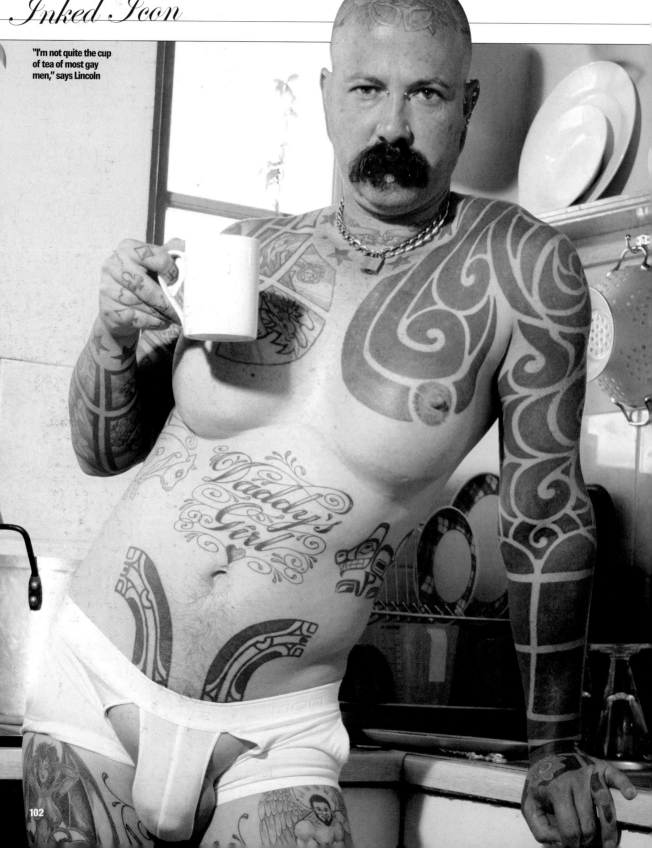

"I'm not quite the cup of tea of most gay men," says Lincoln

didn't do a hell of a lot for me. I like other elements of the male body shape so I wanted to keep those, and I feel better with male hormones. When I explored the idea of transgender or transsexual and asked myself the question, "Is that what I am?" it didn't feel right.

Did you have to buy a new set of clothes?
I haven't had to change my wardrobe that much. I've found that women's button-down shirts, being more tailored, fit quite well, except for the sleeves being too short. I've got a few of those, but I'm not into anything too frilly. I like wearing tighter T-shirts, so I cut slits down the front of some of my tight ones to make space, but most of them stretch to accommodate. I like showing off wherever it's reasonable and warm enough, and female clothing doesn't generally fit my frame, so I stick to medium-fit men's clothes or stretchy T-shirts.

"I DON'T WEAR A BRA. THEY'RE MADE IN THE LOWER LEVELS OF HELL"

What about a bra?
I choose not to wear a bra. I tried wearing one, but they don't make bras that are designed to go around a male body shape, and they were undoubtedly made in one of the lower levels of hell by a man who never had to wear one. Because the implants are inside, it creates that extra scar tissue around the capsule that acts as a kind of bra structure. Because the implant itself is in a gel shape it's not like a woman's breast, which is free-floating, can shift around and can droop.

Is it easier having a partner who also has breasts?
Having a male partner with breasts is great! We both know how sensual it is to have boobs, so neither of us is scared or self-conscious. I think a guy with breasts is very hot, and being one and having a partner who has his own, is very, *very* hot. We have great fun playing with and learning about ourselves and each other in an uninhibited way. Most gay guys are quite conservative in their sexual tastes and their lifestyles. Most aren't 'queer' or interested in trying different ideas on for size, so I'm not quite the cup of tea of most mainstream gay men. Even many transsexual people don't quite get why I'd want to remain male but have breasts, since many of them are happy to go from one gendered box to the other. Good luck to them, but it means that the GLBTI [Gay, Lesbian, Bisexual, Transgender, Intersex] community are sometimes a little threatened by us. In fact, I often feel more comfortable in straight circles than in gay ones. **B**

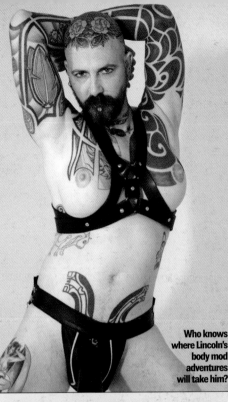

Who knows where Lincoln's body mod adventures will take him?

MORE MODIFICATION
BREAST IMPLANTS ARE ONLY THE BEGINNING...

Having breast implants is only the tip of the iceberg for Lincoln, and he's now joined forces with artist Chris Diedericks on The Embedded Form Project.

The project entails "the creation and exhibition of body-based and inorganic pieces incorporating the male human body as an art-piece, to challenge the limits of privacy, objectification, ownership and the nature of the artist", and as part of the venture Lincoln's body will be further sculpted with breast, muscle and facial implants, to achieve a hyper-stylised vision of masculine 'beauty'.

The project will launch with pieces co-created by Lincoln and Chris, which will include breast prostheses removed from Lincoln after a breast enlargement procedure. The proceeds from the sale of these pieces will fund further surgical sculptures.

The artists are offering sponsorship opportunities for specific parts of the project, each of which will entail further surgery and the creation and exhibition of artworks. Sponsors will be able to contribute in a variety of ways, including funding surgery and assistance with exhibition and publicity, and will, if they wish, be credited for their patronage.
For more info contact Lincoln@idws.co.za, and to see Chris' work check out Chrisdiedericks.co.za

ANIMALS

FROM MYTHICAL BEASTS TO DEARLY DEPARTED PETS, *BIZARRE* READERS' FLESH IS CRAWLING WITH CREATURES

ANDII
Who did it? Mark Wood, at his home in Tasmania, Australia.
What is it? A Tasmanian wolf spider.
Why did you choose it? I wanted to win a tattoo competition, and I find spiders fascinating.
How do you feel about it now?
Despite all the weird looks I get, I still love it.

CLAIRE WILLIAMS
Who did it? Adam at New Wave Tattoo Studio, London, UK.
What is it? A 17th-century seahorse design used on Ruckers harpsichords.
Why did you choose it?
I'm a harpsichordist. I had it done on my lower back, my core, where my love for early music has taken hold.

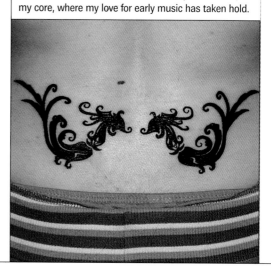

DOUGLAS BEARCHELL

Who did it?
Mike in Raptor's, Edmonton, Canada.
What is it?
A great white shark.
Why did you choose it? I love sharks.
How do you feel about it now?
It's something I know I won't grow out of.

BOO BOO KITTY FUCK

Who did it? Joe at Joe's Tattoos, Beccles, UK.
What is it? A tiger, in a tribal style.
Why did you choose it?
I had it done as big cats spiritually represent feminine power and energy, and at the time I was going through a lot of nasty shit. I think I felt the tiger could watch my back!

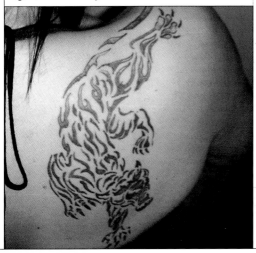

BARRY ARNOLD

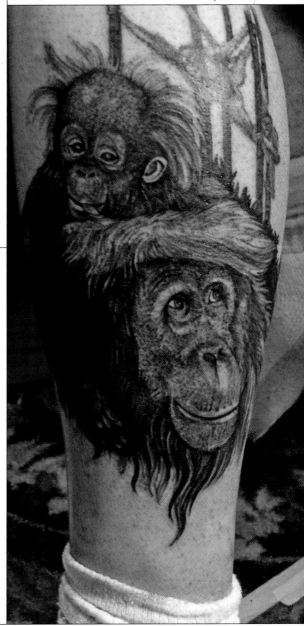

Who did it?
Patti Colebank at Thinkin' Ink, Worthington, USA.
What is it? An orang-utan.
Why did you choose it? Patti picked the design.
How do you feel about it now? I couldn't be any happier with the design if I'd picked it myself. ➡

KITTIE

Who did it?
Terry at Deep Blue Tattoo, Eastbourne, UK.
What is it?
A pair of deinonychus dinosaurs.
Why did you choose it? I wanted a variation on the classic swallow tattoo, so I decided to go for a kind of dinosaur as I'm studying palaeobiology.

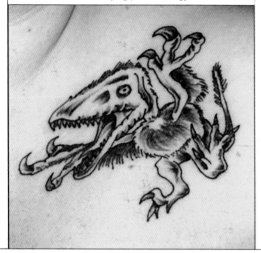

HANAH

Who did it?
Dave at One Shot Charlie's, Stourbridge, UK.
What is it?
A phoenix rising from the flames.
Why did you choose it? It represents new beginnings.
How do you feel about it now? I can't wait to get it coloured and my entire back covered to match.

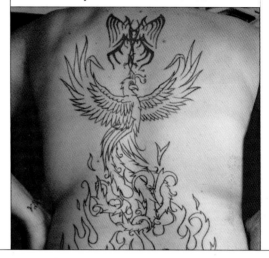

LISA COCKAYNE

Who did it?
Carol at Studio 81, Manchester, UK.
What is it?
Pegasus the flying horse standing in water by an old tree, with a full moon and stars.
How do you feel about it now? I'm so proud of it. But I wish I could see it without looking in the mirror.

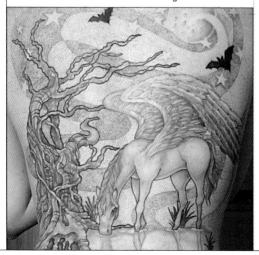

SAMANTHA DOYLE

Who did it?
Irish Steve at Steel Beauty, Gants Hill, UK.
What is it? Dragonflies, as they're such beautiful creatures.
How do you feel about it now? Great. My tattooist was amazing, and his shop is the only place I'll get more work done as it has such a great atmosphere.

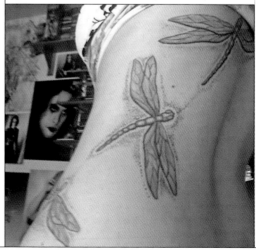

RICK FARN

Who did it? Jo Harrison at Modern Body Art, Birmingham, UK.
Why did you choose it? I went through a tough time, but decided I wanted to put my life back on track and came up with the phoenix.
How do you feel about it now? It's totally changed how I think about myself in the most positive way.

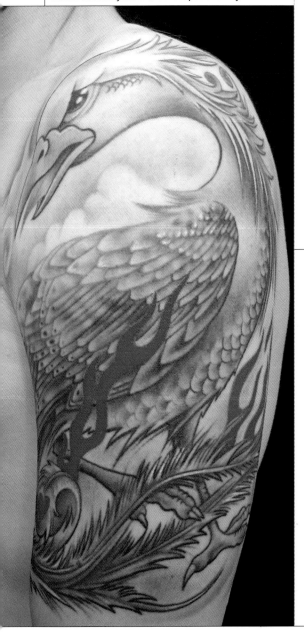

MICHAEL ATWOOD

Who did it? Ben Boston at The Tattoo Studio, Bristol, UK.
Why did you choose it? It was the most dumb thing my friends could think of as a bet, plus I have an overtly sexual attraction to otters. It gives me something to look at when I'm stroking myself.

PETER MALLIN

Who did it? Bo at Lonely Beach, Koh Chang, Thailand.
What is it? A gecko emerging from my ass.
Why did you choose it? It was a Christmas present from my girlfriend. I'd always fancied this tattoo, and wasn't going to turn down the chance of a free one. Ⓑ

Pauly Unstoppable's nostrils and earlobes have been stretched to incredible proportions

Modding and
BIG EARS

IF YOU CAN'T HANDLE THE THOUGHT OF NEEDLES, SCARS OR BRANDING, STRETCHING COULD BE BODY MODIFICATION FOR YOU

WORDS **AMY SALTER** PHOTOS **BMEZINE.COM**

One of the simplest processes in body modification, stretching involves making a hole in a chosen body part – commonly the earlobe – and stretching it by inserting ever-bigger objects. This action makes tiny tears in the skin, which then heal over time.

Mac McCarthy, who runs Punctured Body Piercing and Modification in Devon, UK, started stretching his ears 12 years ago. Now able to wear plugs up to 25mm wide, Mac says the only way people can get to that size without causing damage is by having patience; although everyone heals at different speeds, you should only stretch 1mm at a time every four to six weeks.

Also bear in mind that, if you don't want saggy earlobes, you shouldn't go past a 6mm gauge. And while everyone heals differently, there's no guarantee holes will shrink back to their original shape. That makes stretching a big commitment.

Mac agrees: "Stretching is a life-changing decision – most of the time it's irreversible. Holes will close to a certain extent, but if you go past a certain size you're going to be stuck with them."

Nowadays, people are stretching ears, lips, nipples, genitals, navels, septums and tongues. In fact, if you can put a hole through it, you can make that hole bigger.

The techniques for stretching different body parts are roughly the same, with the general rule being to have patience, watch how your body responds, and seek advice from the pros.

The most common method of stretching is Tapering – a taper is a round bar with different-sized ends that coincide with your next stretch. After being lubed up, the narrow end is pushed through the hole and the new jewellery is positioned against the wider end. The whole thing is then pushed through, leaving the jewellery in place. ➡

Another common method is called Tape Wrap. The process involves taking your current jewellery and wrapping it in a layer of Teflon or bondage tape. Then, when your current size is healed, another layer of tape can be added and so on.

Dead Stretching is also practised – this involves forcing new jewellery into an existing hole using no equipment. However, this can cause the hole to invert, or even tear the skin and leave a right mess.

Weights – as well as large or heavy jewellery – have also been used by some stretchers to pull the skin down. However, this can dramatically decrease the bloodflow and lead to a thinning of the lobe, or cause ears to sag rather than stretch evenly.

A more painful process is to make an incision using a scalpel, before inserting jewellery with a taper. This allows for instant progression to wider gauges. A similar method, Dermal Punch, involves punching out a circle of flesh and filling the hole with jewellery. However, due to the removal of skin, Dermal Punching makes it difficult to carry on stretching to larger sizes or revert to a smaller hole.

During the stretching process, people are encouraged to let their ears relax every day by removing jewellery for a few hours. This increases the bloodflow which, if restricted, can lead to thin lobes that aren't suitable for further stretches.

However, stretching doesn't come without its problems. Impatient folk who stretch too quickly can end up with a 'blow out', which generally happens within 48 hours of the procedure, where the hole is under too much pressure and

The holes in Bear Big Ears' lobes are over five inches long

"STRETCHING IS A LIFE-CHANGING DECISION AND IRREVERSIBLE"

twists inside out, leaving a flap of skin on the back of the piercing. The jewellery must then be removed and downsized, otherwise surgery will be required.

As with any piercing, 'migration' – when the body takes a disliking to the object being impaled through it and rejects and forces it out – can occur. This isn't common when stretching earlobes, but is more likely if you're prone to sticking particularly strange things through the hole.

Mac confirms that impatience is a tricky issue: "People tell me, 'I've stretched 3mm and I'm going to do it again next week,' but they're only causing problems." One of these problems is 'weak spots', where the skin on a person's lobe thins and splits. As well as being painful, tears can also cause scars and make future stretches almost impossible.

THE LONGEST STRETCH

The world record for the largest earlobe stretching is thought to be held by Bear Big Ears (above), whose holes are over five inches long. And if Bear is the biggest player of the ear-stretching world, one of the chief nostril stretchers has to be Pauly

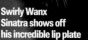

Swirly Wanx Sinatra shows off his incredible lip plate

TATT FACT

Explorers collected the tattooed heads of dead Maori tribal chiefs at the turn of the 19th century, and many native New Zealanders were murdered for their tatts

With patience, you can stretch your piercings to any size you like

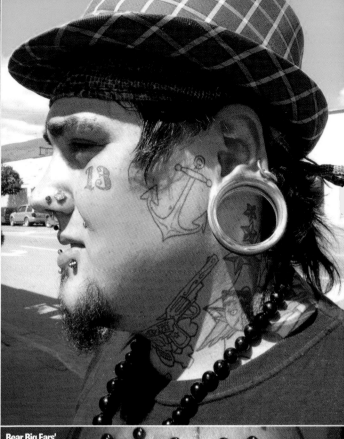

Bear Big Ears' body mods include more than stretched lobes

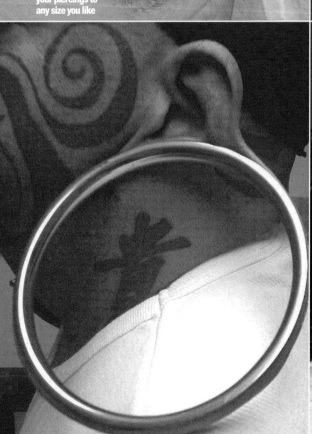

111

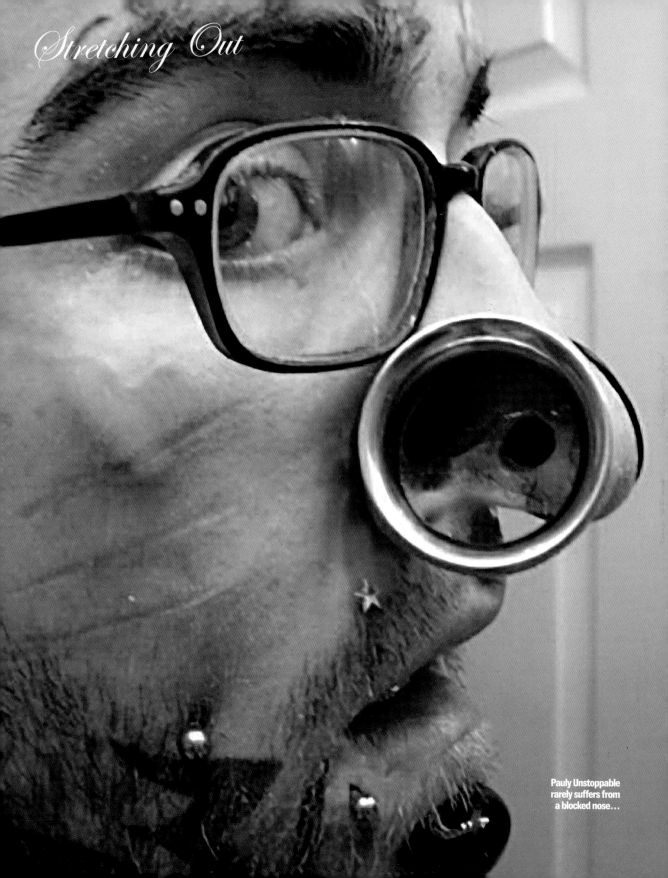

Pauly Unstoppable
rarely suffers from
a blocked nose…

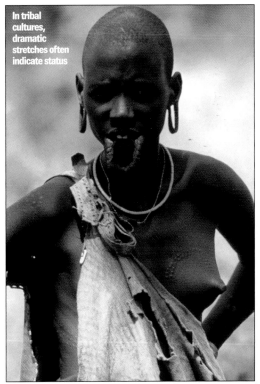

In tribal cultures, dramatic stretches often indicate status

"WHEN I'M OLD I'LL HAVE BIG HOLES IN MY EARS AND BE COVERED IN INK"

Unstoppable (see photo on opposite page), a tattooed and pierced 22-year-old from Indiana.

Pauly claims he's been shot, stabbed and pronounced legally dead for eight minutes. But more importantly, he's got bloody big nostrils. The seemingly cursed one admits his nose – along with his stretched lip, earlobes and numerous tattoos and piercings – put some folk off, but, like most stretchers and body modders, he really couldn't give a monkey's.

Mac has also been stereotyped by people who think he's a "scumbag who's going to mug their granny". But he assures us that couldn't be further from the truth: "I'm one of the most genuine, honest guys around and I run a very reputable business. When people get to know me they change their opinion.

"When I'm old I'm going to have big holes in my ears and be 80 per cent covered in ink. But I've made that choice and just think, yeah, that's exactly what I want to look like." ⑬

THE HISTORY OF STRETCHING
FROM TRIBAL RITES TO THE PRESENT DAY

Body modification has a deep history in tribal cultures across the world, and stretching is no exception.

In Borneo, earlobe stretching was popular among female tribe members as it was considered a mark of true beauty. For other cultures, earlobe and lip stretches signified social status – the bigger the stretch, the more respect you could demand. Inuit tribes, for example, used lip stretches to display social status, as well as to signify a boy entering manhood when he reached puberty.

Other notable stretchers include one of the oldest mummified bodies to ever be discovered: Ötzi the Iceman walked the Earth in approximately 3300 BC, and had earlobes stretched between seven and 11mm.

Tutankhamun, the most famous Egyptian pharaoh, also had visibly stretched lobes, and if you take a close look at images of Buddha you'll notice his lobes are stretched lengthways; it's said that as a prince Buddha wore heavy jewellery which permanently lengthened his earlobes, and subsequent images of the 'awakened one' portray this.

Rising Fawn, aka Major George Lowrey (1770-1852), was the Assistant Principal Chief of the Cherokee Nation, and can be seen in portraits with earlobe stretches so long they'd put most of today's body modders to shame.

In the modern world, many tribes in Africa, South America and Asia continue to bear phenomenally stretched ear and lip piercings. Along with branding and cutting, such body modifications are an important tradition for these people and are often a symbol of identity, beauty and individual worth.

Meanwhile, although stretching has become increasingly popular among Western subcultures, the reasons people give for choosing to stretch holes in their bodies are wide and varied: some people enjoy the way a stretched hole feels; others who've stretched their nipple piercing have pointed out the pleasurable sensation they get from the weight of large jewellery; and, like tattoos, many people find the process addictive, and won't stop stretching until they feel as if they're 'done'.

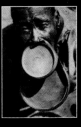

Stretching has its roots in tribal culture

THORN

Age: You should never ask a lady that.
From: Kent, UK.
Who did your tattoo? Les at Garage Ink, Margate, UK.
Why did you choose this tattoo? The Ragdolly Anna on my right arm is a drawing of my childhood toy, who was also my best friend who I told all my secrets.
How do you feel about it now? I can't imagine myself without this tattoo. It's become a part of me.
What inspires your tattoos? I just get tattoos I like.
What tips would you give a tattoo virgin?
Choose your design well. Don't just walk in and pick a design on a whim, as it'll be with you forever.

BIZARRE'S
ultra
vixens
Tattoos

THE ULTRA VIXENS ARE *BIZARRE*'S HOTTEST READERS. MEET THE GIRLS ONLINE OR JOIN OUR WILDCAT WEB COMMUNITY AT BIZARREMAG.COM/ULTRAVIXENS

COMPILED BY **DENISE STANBOROUGH**

ANGEL

Age: 25.
From: London, UK.
Why did you choose this tattoo? Hunter S Thompson is my hero and I've always wanted a tattoo of him on my arm. When he died, it made me want to get it done.
How do you feel about it now? I love it. I recently had the words 'He who makes a beast out of himself gets rid of the pain of being a man' added to it, and I plan on getting the sleeve finished very soon.
What tips would you give a tattoo virgin? Make sure you see the tattooist's portfolio and speak to other people they've tattooed. And don't go cheap! ➡

LUCY

Age: 25.

From: Darlington, UK.

Who did your tattoo?
Alison Manners at Ultimate Skin Tattoo Studio, Leeds, UK.

Why did you choose this tattoo? I love Roman Dirge's *Lenore* comic the characters come from.

How do you feel about it now? I love it.

What inspires your tattoos? Anything and everything.

What are your tattoo pet-hates? I have too many!

What tips would you give a tattoo virgin?
Don't get too many little tattoos because you'll regret it if you decide to get a full back piece or sleeve.

LAURA THERESE

Age: 23.

From: Newcastle and Glasgow, UK.

Who did your tattoo?
Alan at North Side Tattooz, Whitley Bay, UK.

Why did you choose this tattoo? I was brought up a strict Catholic and felt my constant rebelling had ruined me. So I got 'Ruined' tattooed on me as a souvenir!

How do you feel about it now? I love my tattoos. Each one is an expression of my state of mind.

What tips would you give a tattoo virgin? Go with your first choice. Who cares what you look like when you're 60? I can't wait to be a tattooed corpse!

FRAGGLE

Age: 30.

From: Gloucester, UK.

Who did your tattoo?
Amanda West at Alzone Tattoos, Gloucester, UK.

Why did you choose this tattoo?
I designed it myself and Amanda developed it.

What inspires your tattoos? The happy world inside my head that I live in more than the real world.

What tips would you give a tattoo virgin?
Don't listen to people who tell you it hurts – they're talking shit! Everyone feels pain on different levels, so just get on with it and don't fanny about. ➡

TATT FACT
Sailors once believed that the word 'hold' tattooed on the knuckles of one hand, and 'fast' on the other, allowed the bearer to grip the rigging more tightly

Vixen Tattoos

TATT FACT
Although its origins are uncertain, the word 'tattoo' is thought to originate from the word *tatau*, which is Tahitian for 'to mark'

SUGAR CAIN

Age: 26.

From: Sheffield, UK.

Who did your tattoo?
Heath at Something Wicked, Lincoln, UK.

Why did you choose this tattoo?
I wanted it for years because I'm a mischievous pixie!

What inspires your tattoos? All sorts. I'm an artist, so I try to do my own designs. I just love art, I guess.

What tips would you give a tattoo virgin?
Find what you like, see it drawn up, then wait for two years. If you still like it, go to the best tattooist you can find. It's a big decision, so don't take it lightly.

SAMANTHA REES

Age: 25.

From: Hull, UK.

Who did it? Dave at Cruithni Tattoo, Hull, UK.

Why did you choose these tattoos?
I like pretty, girly things like flowers and butterflies.

How do you feel about them now?
I've always been 100 per cent sure about my ink.

What inspires your tattoos? I've taken inspiration from song lyrics that are personal to me.

What are your tattoo pet-hates? Shitty tribal efforts.

What tips would you give a tattoo virgin?
Don't go for something that's a passing fad.

SAKURA

Age: 21.

From: Burgess Hill, UK.

Why did you choose these tattoos?
Some of my tattoos have meanings and some don't. My leg is tattooed for reasons only I know, and my arm features designs I wanted to be timeless.

How do you feel about them now? They're all beautiful in their own way. I like the reactions they provoke.

What inspires your tattoos? Me, life, emotions, personality changes… a maelstrom of things.

What tips would you give a tattoo virgin? Eat something before getting the work done. You'll need it. ⓑ

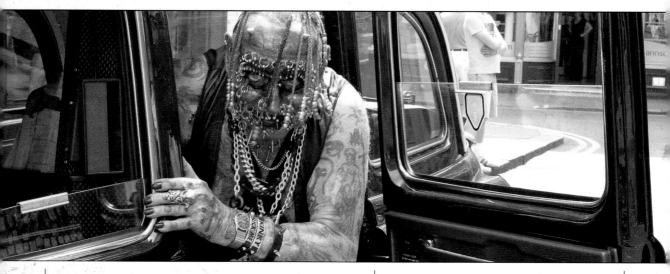

WHAT POSSESSES A BANKER OF 30 YEARS TO GIVE UP FINANCE AND PUNCH OVER 500 HOLES IN HIS FLESH?

PRINCE ALBERT

WORDS **ASHLEY, DENISE STANBOROUGH** PHOTOS **ASHLEY**

When you first catch sight of Prince 'John' Albert, you see a face full of metal, garish facepaint and a dangling, jangling posing pouch swinging menacingly below the hemline of his miniskirt. But when you speak to him, you find a gentle, articulate, well-mannered man who loves life and the way he looks. At 76 years of age, he rejects meals-on-wheels in favour of being the man with the most piercings in the UK.

Bizarre first met Prince Albert in July 2005, and over the years he's landed a role in an MTV dating show (he was the booby prize), and has continued to fill every inch of his body with tattoos and piercings. As Prince Albert says, "I'll never become one of the pipe-and-slippers brigade – I enjoy being a freak and that's not going to change!"

Tell us a bit about your life before you started to change your appearance.

When I left school, I had no idea what I wanted to do. I started working at Barclays bank and stuck at it for 30 years. I got out in the 70s and became the manager of an 'alternative' bookshop, which basically meant it sold gay porn. I did that for seven years. Then I ran a mail-order children's bookshop from home and that was very successful. I'm retired now.

Was it hard to express yourself in the early days?

I was always an exhibitionist. I'd be told off at the bank for wearing shoes with a gold buckle, or because my trousers weren't the right width. One day I went to work wearing a bright blue suit and was told off for that, so the next day I came in wearing an old army pullover and that didn't suit either. I was so pissed off. I've been the happiest in my life since I left that bloody bank.

After living a fairly conventional life, did you reach a point where you just wanted to go wild?

Even as a kid I wanted tattoos. As soon as I'd finished with banking, I went and got some. I knew nothing about piercing at the time, and that all started when I went to a car boot sale in 1996 and picked up a magazine with a girl on the cover called Geraldine from Dublin. She had some fabulous piercings and I thought, "I'd like some of those." And I just went from there.

What was your first piercing?

It was a little butterfly thing on my nose, but there was no backing on it and one day, when I was shaving, I noticed it was gone. The next main one was my eyebrow piercing. The guy who did it was a nightclub bouncer and very heavy-handed. It bled for half-an-hour and hurt like hell, but it didn't put me off. The trouble is a lot of the people who did my piercings aren't available any more. The guy who did my genital piercings has gone out of business for being a bit naughty with his female clients. ➡

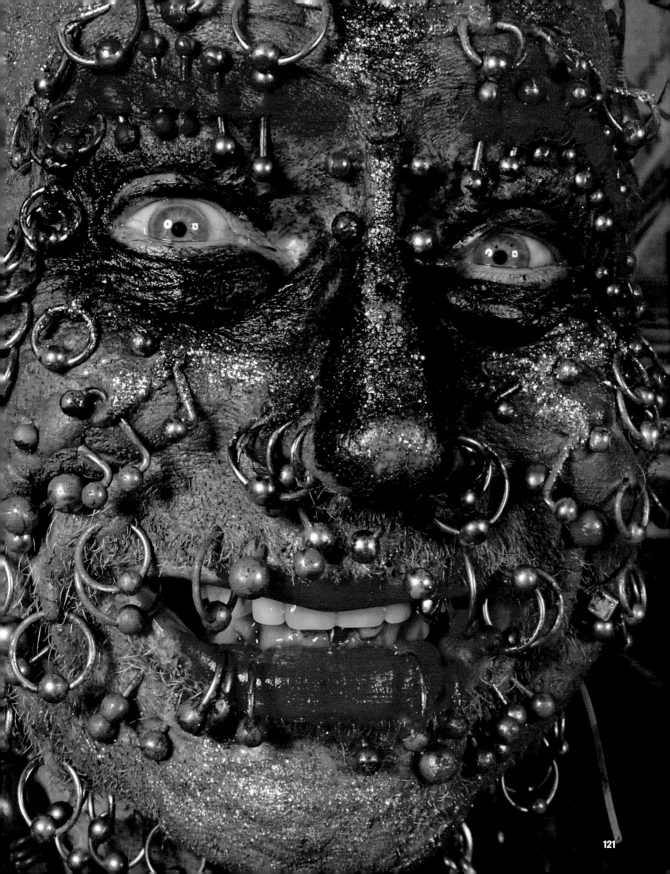

Have you had any piercing disasters?

One time a piercer hit a vein and the blood just started spurting and didn't stop. So they called an ambulance and the owner of the shop banned me from returning for more work. He was worried I'd have a heart attack because of my age.

Do your piercings cause you any difficulties?

No, apart from when I'm shaving. It's not as easy as it used to be – I have to use a nose clipper to get between the jewellery – but I manage. I used to have piercings up my arms, and it was agonising if people knocked into me or I caught one of them on something, but the rest of my piercings don't give me much trouble.

How much have you spent on your adornments?

Quite a bit, actually. I've lost track, but easily a few grand. The transdermal implant horns in my head cost around £500 for the pair.

Why do you wear coloured make-up?

There are tattoos underneath, but they aren't bright enough for me. I think I just enjoy looking quite startling! I wear the make-up most days, or if I'm going out to a restaurant. If I'm staying in, I'll still wear a little bit. I never go out barefaced.

When you started getting work done, did you ever think you'd end up looking like this?

Not in the beginning, but after a while I saw how it was going and was pleased with how I looked, so I decided to carry on. I'd heard about Elaine Davidson, who has about 3,000 piercings and is in *Guinness World Records* for having the most piercings in the world. She inspired me and I've got to know her quite well. She's done a little bit of work on me, but no-one could have more piercings than she has. No-one could top that.

What kind of reactions do you get?

Teenagers love it, and are always thinking of excuses to talk to me. Some little kids are a bit nervous – there was one child the other day who looked quite distressed when she saw me, so her mother brought her over so she'd see that I wasn't going to bite her! Very rarely do

"I WANT TO RECLAIM THE WORD 'FREAK' SO THAT IT'S USED IN A POSITIVE WAY"

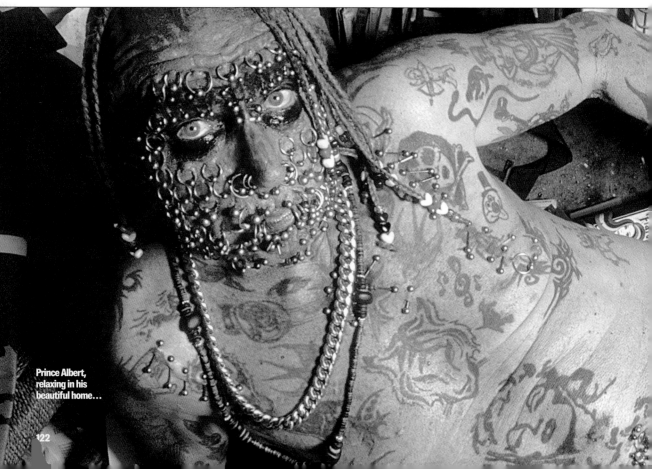

Prince Albert, relaxing in his beautiful home…

I get people shouting things at me, although I often get the builder-types in their white vans shouting "Wanker!" but I just shout out back "And you, mate!"

So you've never had anyone be physically violent?

Well, almost. I was in a hotel one Sunday evening and there were some travellers in there. They called me over and I just thought they wanted to talk, but they started giving me little punches and pushing me about. Luckily, the manager came over and asked them to leave. The police were called and they were barred from the premises. But I generally get a good response from the people I meet.

Do you feel a bit like a tourist attraction?

I do, I love going to Camden Town in London and chatting to the tourists and letting them take pictures.

You must enjoy the attention.

Sometimes I get a little weary of the same questions, but it's generally OK. As soon as I step out of my front door, I can't avoid it. At the supermarket little kids always come over to me and ask "Does it hurt?" and "How many piercings do you have?" The usual things.

What's your average day like?

It depends – if it's too hot or cold I stay in. I sometimes visit the Jubilee Centre in St Albans for elderly people, but the food's not brilliant. They have a roast on Wednesday and I usually go in for that. There are a few hostile retirees who complain if they get a chance. If I'm wearing a skirt they try and make out they can see my bits, things like that. But most are OK. There's one guy, Eddie, who has a lady friend in Hove who he visits once a week; when he goes there he always picks up some gay porn magazines for me, which is nice.

Do you ever regret the changes you've made to your body?

No.

Never once?

Never. A woman at a tattoo convention said to me, "You'll regret those when you're old." And I said, "I'm old now, love!" I'm lucky because what I've done doesn't affect my life that much. I'd say to young people to never have work done that would interfere with their employment prospects. Have tattoos, sure, but have them in places where they won't affect your job options.

Does being labelled a 'freak' annoy you?

No, not at all. I don't think of the word 'freak' in a derogatory sense, it's just part of what I do. I feel ➡

123

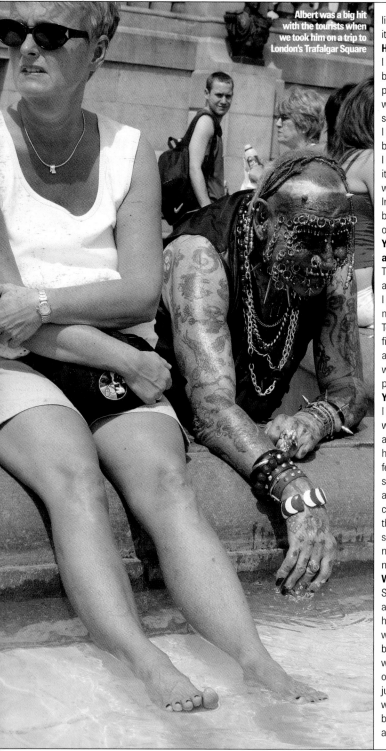

Albert was a big hit with the tourists when we took him on a trip to London's Trafalgar Square

like I'm helping to reclaim the word 'freak' and allowing it to be used in a positive way.

How are you received in other countries?

I love Vienna; I've been there a number of times. I'm better known there than I am here. They're very friendly people, and I can walk back to my hotel after midnight without any fears. I had a hard time at JFK airport, so it'll be a long time before I go to New York again. I was on my way home, and they went through all my baggage and strip-searched me. They obviously thought I was up to something, and when I got back to Heathrow it happened all over again. It was awful, although they were very nice on the plane and gave me a cup of tea. In New York the people were fine; a cop car rolled up beside me when I was sitting on a bench and the officer asked how many piercings I had.

You were in the local news in 2003 after an accountant refused to complete your tax returns.

That really annoyed me. I went along and gave the accountant my bits and pieces, but a few days later I got a letter saying he couldn't do the work for me as my appearance upset him. I wouldn't mind, but he had Tourette's syndrome! The funny thing was that, after our first meeting, I didn't need to see him again as he had all the paperwork he needed. He also said I stank, which was charming. I was so incensed I contacted the local paper and they ran a story on it. It was ridiculous.

You're openly gay now, but you were married once.

I was married for 20-odd years and we had a daughter, who I don't speak to. It's nothing to do with my appearance, although she doesn't like it; we actually had a falling out before I did all this. I sent her a letter a few years back when I was quite ill, as I thought she should know, and I had a letter back. But I haven't actually spoken to her in years. My daughter has two children and I tried to get in contact with them. I thought, "They haven't done me any harm, so when I snuff it they can have a share of what's going," but they never replied and I've just written them off. I'd prefer it not to be this way, but I'm used to it now and live with it.

What about your wife?

She found somebody else, someone I introduced her to, and she became obsessed with him. I was very fond of her and still liked her, but I told her to have a relationship with this person and get it out of her system, then come back to me after a few months. But she never did. She went up north and got involved with a bad crew, then one day she crossed paths with a mental patient who'd just been released, and he knifed her to death. This guy was a real loony, but they caught him and sent him back to the asylum. I didn't go and identify the body or anything, her brother did all that. At the time when the

"I generally get a good response to my piercings," says Albert

"I WAS MARRIED FOR TWENTY YEARS AND I HAD A DAUGHTER. WE DON'T SPEAK NOW"

news came through I was working in my bookshop and my first thought was, "God, what was I doing yesterday?" in case they tried to pin it on me.

How do you get over something like that?

You just do, you get on with it. As I said, I was very fond of her, but I wasn't in love. We met when she was quite young — I was on a youth-club trip to Wales and met her outside a chip shop and we made a date. She was very attractive and it went from there. Then she found out she was pregnant and we married, which I did want at the time.

When did you realise you were gay?

I was very uncertain about my sexuality when I was at school — I fancied certain girls, but I was also happy to go down the fields with a male friend and masturbate. So I was torn between the two, and still was when I met the wife. It was during that period that I thought I must be bisexual.

Did your wife know about your sexual preferences?

Oh yes! As time went on I was finding it slightly difficult to perform, so I had a male nude book by the bed and would glance at it to keep me going.

That must have gone down well at bedtime…

I didn't do it blatantly!

What do you think your parents would make of you?

My mum, after a little hesitation, would take it in her stride. My father wouldn't be so keen, but he'd be alright after a while. When I look at old photos, I used to wear some ridiculous things and he managed to deal with it.

Do your genital piercings hinder sex at all?

I haven't had sex for a while, so I'm not sure. I don't think it would be a problem. When I rang a medical helpline recently about prostate problems, they said I should ejaculate every now and again. I already was, but it's nice to be told I should do it!

If you hadn't modified yourself in this way, what do you think you'd be doing now?

If I hadn't got into this, I'd probably have just sat around and watched the box. Instead I have lots of young friends, I enjoy their company and I get to travel around a lot. Having said that, I get a free TV licence later, so there are some benefits to being old! ⓑ

SYMBOLIC

THERE'S OFTEN MORE TO YOUR TATTOOS THAN MEETS THE EYE. HERE'S SOME INK WITH A STORY TO TELL...

PAUL WILCOCK

What is it? It's the tattoo that the ninjas from G.I. Joe have. I loved them as a kid, and still do.

How do you feel about it now? It reminds me of my childhood and makes me feel like a ninja. Girls either want to stroke my tatt, or have a 'what the hell is that?' look on their face.

DANA

Why did you choose it? The Sanskrit text means 'the power of faith', because everything I do is based on having faith in my instincts.

How do you feel about it now? The dragon isn't finished, by choice, as it represents the dragons I've been slaying metaphorically throughout my life.

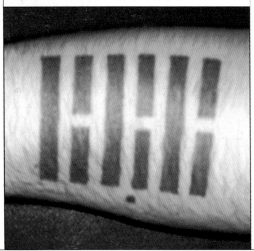

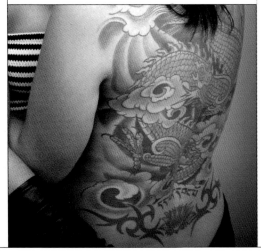

MARIANNE RIDLEY

Who did it? Nutz at Fantasy Fine Line, Maidenhead, UK.
Why did you choose it? It's my own cat's paw print, but he went a bit spazzy when I put his paw in the ink.
How do you feel about it now? It was a present for my 18th birthday, and will always remind me of that time.

TARA HERRON

What is it? A character I created, Dana.
Why did you choose it? Dana represents my dark side, and embodies everything in me that's depressed, insane and awkward. She's what I'd be like if I lost my mind.
How do you feel about it now? Dana is my most meaningful tattoo.

HANNAH LEWIS

Who did it? Ian at No Limits Tattooing & Body Piercing, Reading, UK.
Why did you choose it? I got it done when I was finally comfortable with my body. It symbolises becoming a woman.
How do you feel about it now? I really love it. I'm so proud to have such amazing art on my body. ➡

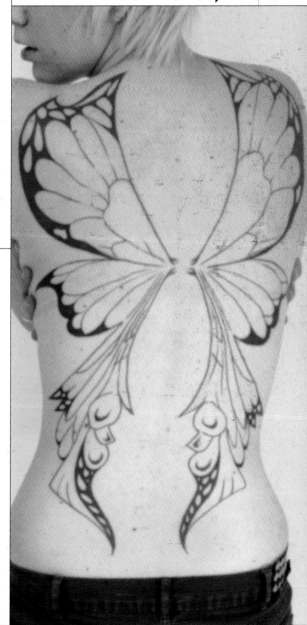

MANTHA

Who did it?
My best mate Aysha, in her shed.
What is it?
Angel wings and hieroglyphics spelling the word 'fallen' – you work it out!
How do you feel about it now?
I love it, even though I can't see it.

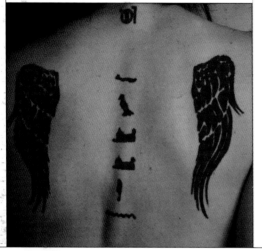

RANDII

What is it? A leopard print sleeve.
Why did you choose it? I have a leopard print obsession! I play in bands, currently Sweet Seduction, and always decorate my drumkit with a leopard design. It's become a trademark for me, and when I get a new kit I'll doubtless cover it in another leopard print.

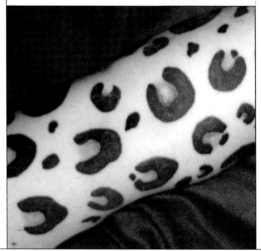

STEPHEN PANG

Who did it?
Chris at Ian's Of Reading, Reading, UK.
What is it? A soul dragon over some Chinese writing.
Why did you choose it? The dragon and Chinese writing has special spiritual meaning to me.
How do you feel about it now? I love my tattoo.

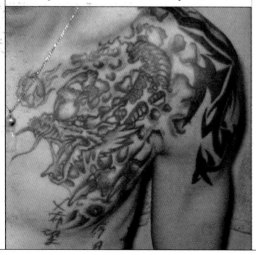

KETRYNA TURNER

Who did it?
Ian at No Limits Tattooing & Body Piercing, Reading, UK.
What is it? Elvish writing.
Why did you choose it? I got it done to show my love for the *Lord Of The Rings* films.
How do you feel about it now? I love it. Elvish is sexy.

ELEANOR BOWTELL

Who did it? Becky Prizeman at Eternal Art, Upminster, UK.
Why did you choose it?
I have a real appreciation for nature in body art, and it's a feminine design that contradicts the 'butch' stigma of being heavily tattooed.
How do you feel about it now? I feel highly individual.

ADELE TURNER

Who did it? A Malaysian artist at Studio 81, Manchester, UK.
What is it? A song lyric in code.
Why did you choose it?
I fancied something different and original.
How do you feel about it now?
I still love it, but I have to wear sleeves to work.

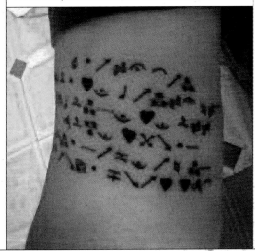

BECKIE JEZZARD

Who did it? Lal Hardy at New Wave Tattoo Studio, London, UK.
What is it? I came up with the design, inspired by the photos of German plant collector Karl Blossfeldt from the late 19th century.
How do you feel about it now? I don't think twice about it now – it's been there for 12 years! ⓑ

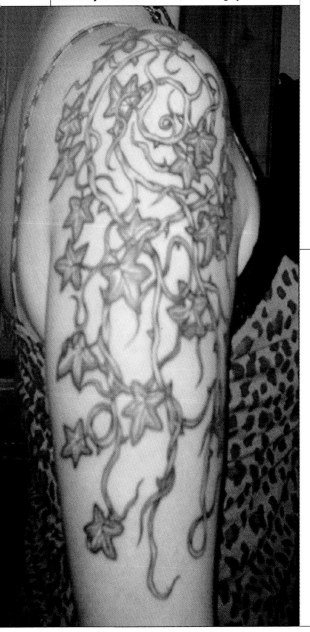

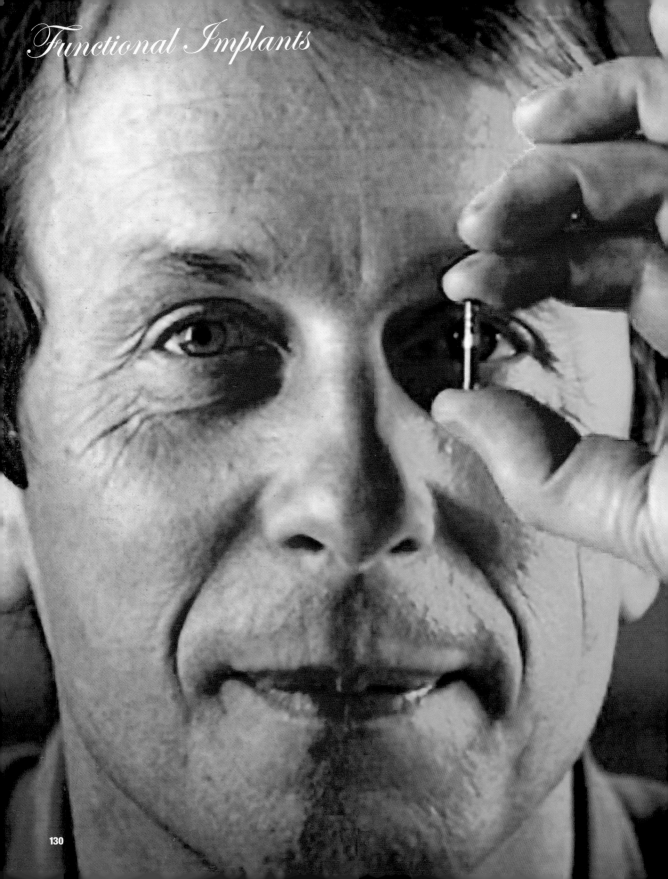

I, Cyborg

FROM MICROCHIPS THAT PAY FOR YOUR BEER TO IMPLANTS THAT CAN SAVE YOUR LIFE, THE CYBERPUNK DREAM OF MAN FUSING WITH MACHINE IS BECOMING A REALITY. THIS IS THE FUTURE OF BODY MODIFICATION

WORDS **DENISE STANBOROUGH**

*I*magine having a body modification that allowed you to control anything, from how much money you spend to switching on the lights or opening doors… all without lifting a finger. It may sound like science-fiction, but some people have already upgraded themselves with implantable technology to get special powers and extra senses.

Steve Haworth is best known for his work in 3D body art (see page 44), but in 2006 he inserted silicone-coated neodymium magnets into Todd Huffman, a student at Arizona State University. Together they decided that the fingertip was the best place because it has a high nerve density, and your hands are constantly interacting with the world. And while the index finger would seem like the natural choice, they went for the left ring finger as it was "the least critical fingertip in case of damage".

Thankfully, those concerns were unfounded. The implant was successful and suddenly Todd could sense magnetic fields and wave frequencies that normal people never will. In a post on Steve's website, Todd described what it was like: "With the implant I can detect subtle changes in polarity and strength. For a static field, like a bar magnet, it feels like a smooth pressure; imagine running your hand through lukewarm water, and brushing your finger across the top of an invisible marshmallow."

Working with Haworth on the project was body jewellery designer Jesse Jarrell, who produced the implants. "I've been interested in functional implants for a long time," he says. "Aesthetic implants are common, but I've been thinking about electronic assemblies under the skin. Body modification is a diverse field, largely revolving around art and self-expression; functional implants are an offshoot, and this sort of work is more common in scientific and commercial fields."

BIONIC MEN

Another person blurring the boundaries between aesthetic and functional implants is James Sooy, who created the world's first pierced spectacles.

James began toying with the idea of glasses that screwed directly into a barbell piercing during high school. "I got the bridge piercing specifically for the pierced glasses," he says. "They feel like regular glasses because the weight is applied to the nosepads. We made the first pair in December 2004 and I've worn them every day since." ➡

Professor of Cybernetics Kevin Warwick was the first human to be fitted with an RFID, or Radio Frequency Identification Device, which identifies him to his computer

PICTURES: DAVID FRIEDMAN/GETTY IMAGES; JAMESSOOY.COM; REUTERS/CORBIS; ZUMA/CORBIS; KEVIN WARWICK

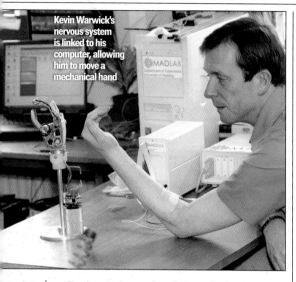

Kevin Warwick's nervous system is linked to his computer, allowing him to move a mechanical hand

A DANGER TO SOCIETY

But while these examples of technology fusing with human beings are exciting, there are concerns about the effect it could have on society. When the Baja Beach Club bar in Barcelona introduced the VeriChip to its VIP patrons in 2004, the media coverage raised questions about safety and data security. Club owner Conrad Chase proved his allegiance to the chip by having one implanted into his own arm. He told journalists, "By passing by our reader, the Baja Beach Club will know who you are and what your credit balance is."

"CHIPPED PEOPLE CAN BE MONITORED AND CONTROLLED BY GOVERNMENTS"

But interesting as the advances from the body modification community are, science is where the biggest advances in functional implants are being made. Amal Graafstra has two Radio Frequency Identification (RFID) implants, one in each hand.

"In my left hand is a unique ID chip, and in my right is a chip with 255 bytes of read/write data storage," he says. "It was implanted by a cosmetic surgeon using a scalpel. A small 1.5mm cut was made in my skin and the implant placed under it. It was done in a matter of minutes. My right-hand implant was injected with an implant needle kit. It was over in about 20 seconds."

The implants enable Amal to open his front door and log on to his computer. His girlfriend Jennifer was so impressed that she had the same procedure; now the pair can gain entry to each other's homes without keys. "It doesn't really profess your love for a person to those around you like a ring," says Amal. "But who knows? People might be implanting chips in their bodies instead of getting tattoos in the future."

Amal has received a wave of emails from people opposed to his implant. And while some voiced religious concerns, security was the biggest worry.

"It comes down to the fact there's no 100-per-cent-secure system, and if someone wants to badly enough it can be broken or hacked," he says. "But if a person attacked you and took your tag ID, it wouldn't let them into any house with RFID – it would only let them into your house, just like if you lost your keys. An attacker would have to target you specifically."

The VeriChip was originally introduced in 2001 to transmit an individual's medical and financial information to reader devices via radio waves. It's about twice the length of a grain of rice and normally implanted above the triceps area of the arm. According to VeriChip's creators, as of May 2007 there were approximately 2,000 people with VeriChips in their body.

But even though they're becoming increasingly popular, they're not perfect. There's potential for these transmissions to be duplicated by other people, and in a letter issued by the Food and Drug Administration in October 2004, electrical hazards, MRI incompatibility, adverse tissue reaction and migration of the implanted transponder were just a few of the potential risks associated with VeriChip implants.

Human-rights groups also warn implantable technology could encroach on civil liberties. Privacy expert Liz McIntyre, who co-wrote Spychips: How Major Corporations And Government Plan To Track Your Every Move With RFID, says we should all be concerned about the future of products like VeriChip. "The VeriChip's been touted as ➡

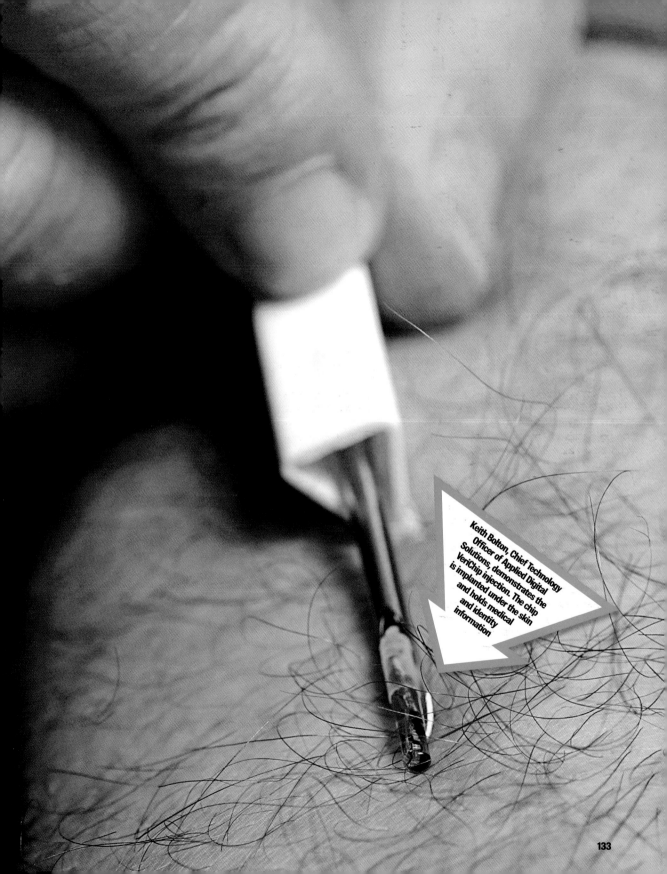

Keith Bolton, Chief Technology Officer of Applied Digital Solutions, demonstrates the VeriChip injection. The chip is implanted under the skin and holds medical and identity information

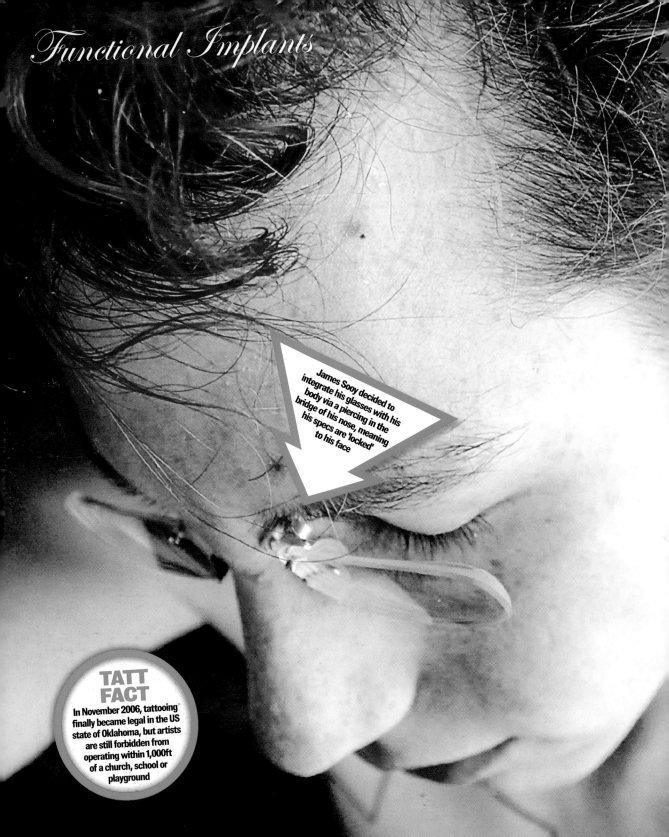

Functional Implants

James Sooy decided to integrate his glasses with his body via a piercing in the bridge of his nose, meaning his specs are 'locked' to his face

TATT FACT
In November 2006, tattooing finally became legal in the US state of Oklahoma, but artists are still forbidden from operating within 1,000ft of a church, school or playground

a way to track kidnap victims, but it's of little use for that purpose," she says. "The current version has a short read range and cannot be tracked directly by satellite. Kidnappers aren't likely to take victims to public places where VeriChip readers might sound an alarm. What's more, the chips can be cut out of the arm. One Mexican gang was nicknamed 'Los Chips' because they would inspect their victims for tracking devices."

Security researcher Jonathan Westhues recently demonstrated how easy it is to clone the unique identification number on the VeriChip by simply bumping into a chipped person while carrying a cloning device hidden in a newspaper. The number can then be relayed to a VeriChip reader, enabling him to take on the identity of that chipped person. "If people were VeriChipped en masse, innocent citizens would be caught up in a surveillance web," Liz claims. "Being numbered and tracked makes citizens less safe. Once citizens can be tracked, they can be monitored and controlled – potentially by their own governments."

Liz predicts "voluntary chipping" will be replaced with incentives, with insurance companies offering discounts to chipped clients. "Say no to the chipping of humans," she says. "This is a threat to civil liberties. We should work to pass legislation that would make it a crime to implant an individual with an RFID device without their consent."

"ONE DAY, HUMANS WILL COMMUNICATE WITHOUT WORDS OR SPEECH"

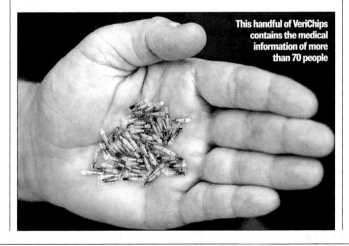

This handful of VeriChips contains the medical information of more than 70 people

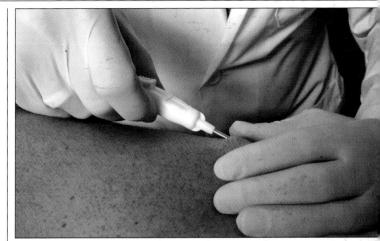

Above: A VeriChip being implanted

MAN MACHINES

However, transhumanists take a very different view and believe new technologies will change the world and render our descendants 'not human'. And considering how technology is advancing, their ideas don't seem so far-fetched.

From emergency-alert bracelets to hearing aids, our integration with technology continues to grow. In 1998, British Cybernetics professor Kevin Warwick demonstrated this by becoming the first human to get an RFID implant, allowing his body to communicate with a computer. In March 2002, he underwent a neurosurgical operation to link his nervous system to a computer and the internet. The experiment lasted three months and enabled him to control an electric wheelchair and an artificial hand.

"Implants have many uses," says Kevin. "There are heart pacemakers, and Parkinson's disease can be counteracted electronically. The ethical questions are clear: Do we let a person suffer, or do we say an implant can assist?" But when it comes to enhancement, he admits "the picture isn't so clear".

"Technology opens up enormous questions for society. It even has the potential to rip society apart between those that have and those that have not. But we can't ignore it. Scientists like me are going to push things forward. And don't think this is all going to happen when you're long dead. The first scientific thought-communication [direct brain-to-brain] experiments will occur within the next 10 years. That landmark will change the world. And within 50 years all humans who want to will be able to communicate without words or speech, simply by thinking with each other via their brain implant connected to the network." ⓑ

FOR MORE INFO VISIT KEVINWARWICK.COM, PIERCEDGLASSES.COM, AND AMAL.NET/RFID.HTML

THE ENIGMA AND KATZEN

WITH FULL-BODY TATTOOS, EXTREME PIERCINGS AND SUBDERMAL IMPLANTS, THE ENIGMA AND KATZEN THE TIGER LADY HAVE DEVOTED THEIR LIVES TO PERFORMANCE ART

WORDS **DENISE STANBOROUGH** PICTURES **JAMES STAFFORD**

The Enigma and Katzen the Tiger Lady are two of the most striking people on the planet.

The Enigma – best known for his time with the Jim Rose Circus and appearing in an episode of *The X-Files* – is tattooed from head to foot in jigsaw puzzle pieces, while Katzen, the only woman in history with a single-themed, full-body tattoo, sports elaborate tiger stripes on every inch of her body, a look completed by Teflon whiskers pierced into her cheeks.

Although the odd couple are now divorced, they made their name together performing sideshow stunts such as sword swallowing, drilling nails into their faces and setting each other on fire.

Tell us about your lives before becoming The Enigma and Katzen. Were you always destined to perform?
Katzen: I was 15 when I started doing street performance in West Key, Florida. I was fire eating and juggling. I was a troublemaker at the time, stealing cars and stuff. I wasn't in with the wrong crowd, it was just me. I had some tragic stuff happen to me. I spent nine months in a mental institute when I was 13. I needed to get back on track, and art took me out of that. Street performance is tough, and you have to work out a fast-paced act. I did a 15-20 minute show because you don't want people hanging around too long or you won't get much money.
The Enigma: I performed at festivals when I was starting out, but didn't have a proper show. I had a desire to make the impossible possible, and incorporated this into being in a band by doing a freaky half-time show. ➡

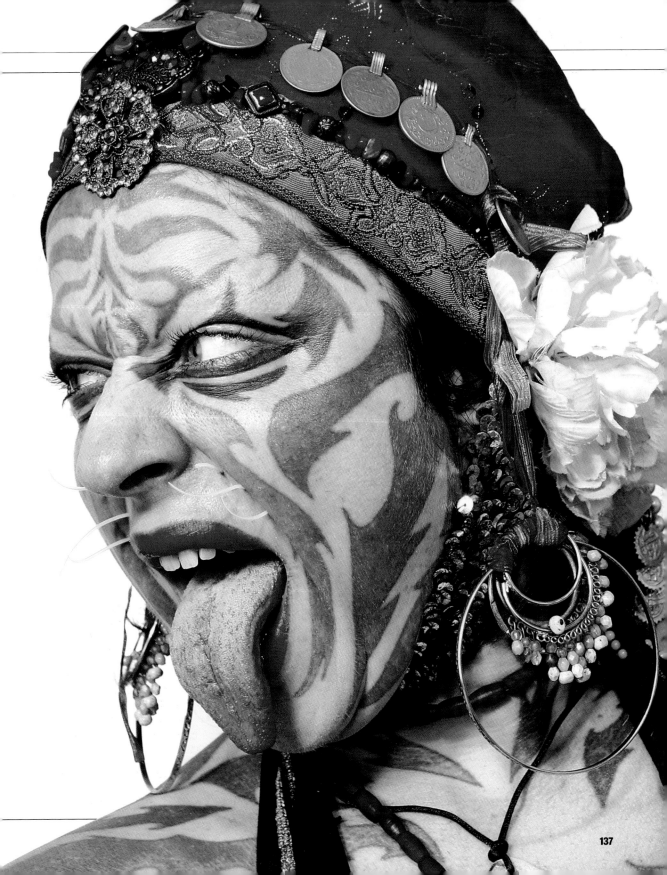

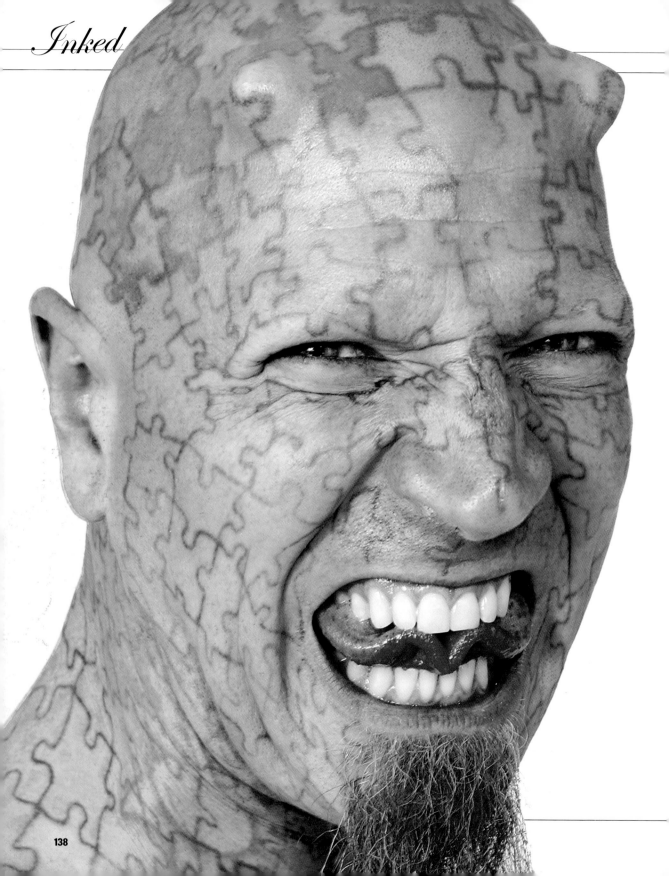

Enigma, you used to be part of the Jim Rose Circus – how did you get involved with that?

E: In the early 1990s I was sword swallowing and lifting weights with my eyeballs, and I hooked up with Torture King, The Amazing Mister Lifto and other people who were involved with Jim Rose. I wanted to improve my act, and I remembered that nursery rhyme about the lady swallowing the fly. I was thinking, "I know an old lady who swallowed a fly… then she swallowed a spider. What about a snake?" Then I thought, "What's like a snake…? A slug!" So I phoned Torture King and said, "I'm gonna eat a slug onstage." When he said, "That's gross!" I knew it was the right thing to do. I was called Slug back then because I swallowed big banana slugs.

How long were you with the Jim Rose Circus?

E: I was there for seven years, but had to leave because the scenery doesn't change unless you're the lead dog.

"WHEN WE FIRST MET, ENIGMA STUCK A COIN IN HIS EYE TO IMPRESS ME"

Where did you guys meet?

K: Lollapalooza 1992 in Atlanta, Georgia.

Was it love at first sight?

K: Attraction at first sight! He stuck a quarter in his eye to impress me, so I invited him over for a cup of coffee. Our relationship lasted a while, but it's over now. But we're still good friends.

E: We discovered we shared a desire to be completely tattooed, and I brought all the equipment so Katzen could start working on me.

K: I did all the puzzle pieces. The tattoos turned Enigma's brown eye blue! Aside from me, he's had over 200 artists work on him.

What motivated you to have such intricate tattoo work?

E: I thought it was cool and I wanted to improve my act.

K: It all started with a dream I had when I was five – in the dream I had stripes, and the world was purple and the sky was green. It made me feel happy, so I started doing paintings of myself with stripes at a young age.

How long did Enigma's puzzle pieces take to tattoo?

K: I started the puzzle outlines in January 1993. I worked on him for

three to six hours every day for a month. I'd drawn these puzzle pieces on his ass and he sat down on the toilet and the lines were imprinted on the seat! I started having my tattoos six months later.

Was it hard getting used to your new appearance?

E: You have to *really* want this. Your body and mind follow each other, so if you suffer from depression eventually your body will suffer from it too. It's the same if you change your body, because your mind changes as well. In order to love yourself, you have to love your body and mind as one. You have to think holistically.

How did your family react to your tattoos?

K: My mother was a pagan and I'm an atheist by choice, so she sat me down and we just talked about it. His mom went mad – she found out in a newspaper.

E: My mom was very upset. She actually came by the house, and was a little irate. But I could be the President of the United States and she'd still be calling me up, going, "Are you eating your greens?" or I could be a cab driver and she'd say, "You're going ➤

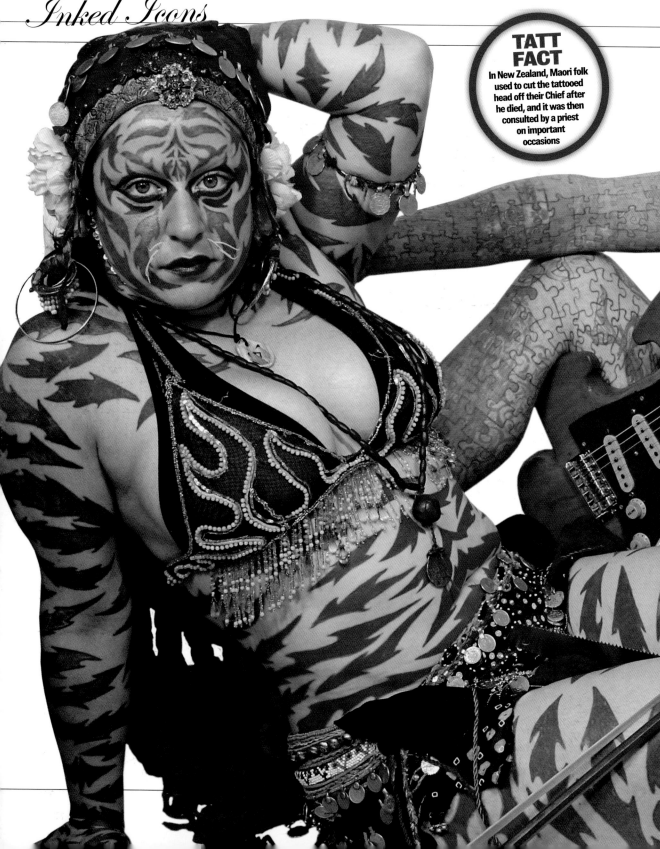

TATT FACT

In New Zealand, Maori folk used to cut the tattooed head off their Chief after he died, and it was then consulted by a priest on important occasions

to kill yourself in that cab." Moms are never satisfied.

How does she feel about it now?

K: She'll go out in public with us now. She never used to do that.

E: We all have to work around our moms. Mothers tend to objectify their kids and stick them in a box, but then they eventually realise, "Oh, you actually have a mind of your own." That's why family isn't always something you're born with – it's something you find.

"TWO TEENAGE GIRLS ATTACKED ME ONCE. I SMASHED THEIR HEADS IN"

What's the general reaction you get from people?

E: You find out who your friends are pretty quickly, but we've had very few negative reactions.

K: I had a homeless guy with no teeth call me 'hopeless' once. That's the pot calling the kettle black!

E: If you want to see the devil, you'll see the devil. If you want to see someone who's prepared to put their life on the line for their art, then you'll see that. We are a reflection of how open-minded people are.

K: I had two teenage girls attack me in New Jersey. I was walking down the street and they just wanted to pick a fight with somebody. I was reluctant to fight them, but they kept pushing it. Then one girl swung at me and as she did I grabbed her arm and took her down to the ground. Her friend was kicking me in the ribs and screaming. I started smashing her friend's head against the ground and was like, "You'd better stop!"

E: If it were me, I'd just squirt them with my stink glands.

Do you ever take offence to the title 'freak'?

E: The term is partially correct, in that we're human marvels and self-made freaks. It's just slang, it's fine. In this modern age, terminology is rarely well-defined. Republicans, Liberals, Conservatives, and Democrats – it's all mixed. I don't think George Bush is very conservative when it comes to lives, bullets, the environment or anything else.

Is it true that Ozzy Osbourne hired you to perform at his birthday party?

E: It was a few years ago, but we went as part of the Lollapalooza sideshow. When The Amazing Mister Lifto was doing his bit, Ozzy's kids weren't allowed to watch.

K: He was lifting weights with his penis and stuff, so you can't really blame them. Ⓑ

For more on The Enigma, check out Theenigmalive. com. Keep up to date on Katzen's life at lam.bmezine. com/?katzen

OLD SCHOOL

TRADITIONAL TATTOOS NEVER WENT AWAY – THEY JUST GOT HARDER, FASTER AND COOLER...

ARMOND DIGIO

Who did it? Christian at Deluxe Tattoo, Las Vegas, USA.

Why did you choose it?
A good friend of mine designed it for me, knowing that I love hearts. It's a symbol of how much pain a human heart can endure, but there's always hope somewhere.

DAVINA FITZPATRICK

Who did it? Steve at Penetrated Ace, Ashton under Lyne, UK.

What is it? Swallows.

Why did you choose it?
I love old-school swallow tattoos. I hunted through tons of tattoo magazines and took everything I liked to Steve, who drew this design for me.

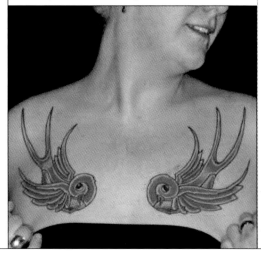

JEN COLLINS

Who did it? Luke B at Kingsway Custom Tattoo, Bath, UK.
Why did you choose it?
I designed it myself – it was an image I'd always wanted tattooed. I love my swallows because they're bright, colourful, and make me feel good every time I see them.

JENNA BIGG

Who did it?
Suzi Q at Reilly's Tattoos, Perth, Australia.
Why did you choose it?
I drew a squiggle that Suzi worked her magic on, and used it to cover up a dodgy fairy tattoo.
How do you feel about it now?
I love it. It's big – which suits me because I'm big too.

TIM GREAVES

Who did it? Stu Muirhead at Hepcat Tattoos, Chelmsford, UK.
Why did you choose it?
I wanted an old-school rock'n'roll, Americana-style design for my arm. I'm a big horror movie fan as well, so I also blended rock'n'roll music and horror imagery on my leg. ➡

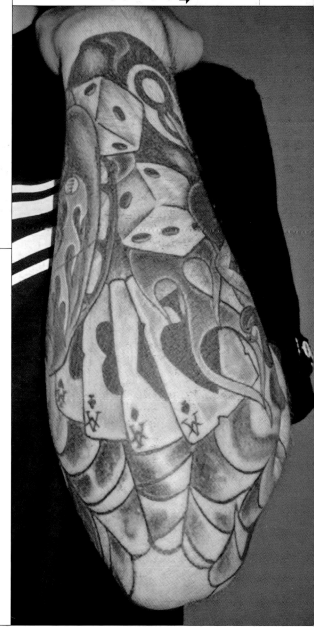

Your Tattoos

JEN HUGHES

Who did it? Kel at Rio Tattoo, Merseyside, UK.

What is it? Old-school with a new twist.

Why did you choose it?
Loads of people have great stories behind their tattoos, but this was my first big piece and my tattooist drew it for me on the day I was having the ink done. No story to tell… how frightfully dull!

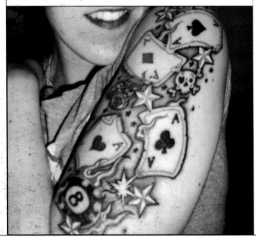

JULIE

Who did it? Bert Du Chene at Sacred Skin, Des Moines, USA.

What is it? Six shooters, roses and banners with my parents' names.

Why did you choose it?
I lost my father when I was 15, and what better way to honour him? My mom would've kicked my ass if I hadn't put her name on too!

KYMBERLEIGH

Who did it? Ahmed at Trader Bob's Tattooing, St Louis, USA.

What is it?
The design is all Ahmed's. It's a heart, that's been crumpled up and put back together with duct tape and string, because that's what I say is holding my heart together.

FAYEZY MULLIGAN

Who did it? Steve at Sunderland Body Art, Sunderland, UK.

What is it?
A Sailor Jerry-style skull and anchor.

Why did you choose it? I designed it myself.

How do you feel about it now?
I love it! Steve did a great job. I couldn't be happier.

TARRIE NOIR

Who did it? Nick Lovene at Far Beyond Tattoo Studio, Luton, UK.
Why did you choose it? It symbolises aspects of my life and family. I love 50s rockabilly, so I wanted it in that style.
How do you feel about it now? It's not too butch, but not too girly. People occasionally lick my arm.

ANNE

Who did it? I've been tattooed by around 25 different artists from across the world, from the United States, UK, France and Holland.
What next? I want to get more, but my only problem is space. But I'll continue getting tattoos until a bus hits me or I run out of white skin.

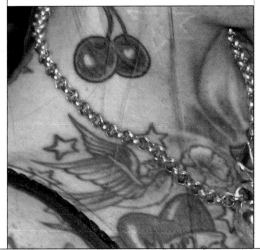

JASON SCHOLES

Who did it? Gary Valentine at Inverness Tattoo Centre, Inverness, UK.
Why did you choose it? When it comes to tattoos, I'm really into bright, bold colours and heavy outlines. Because of this I absolutely love my tattoo! ⓑ

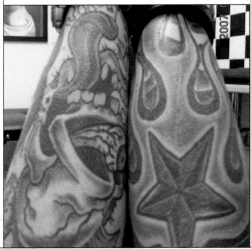

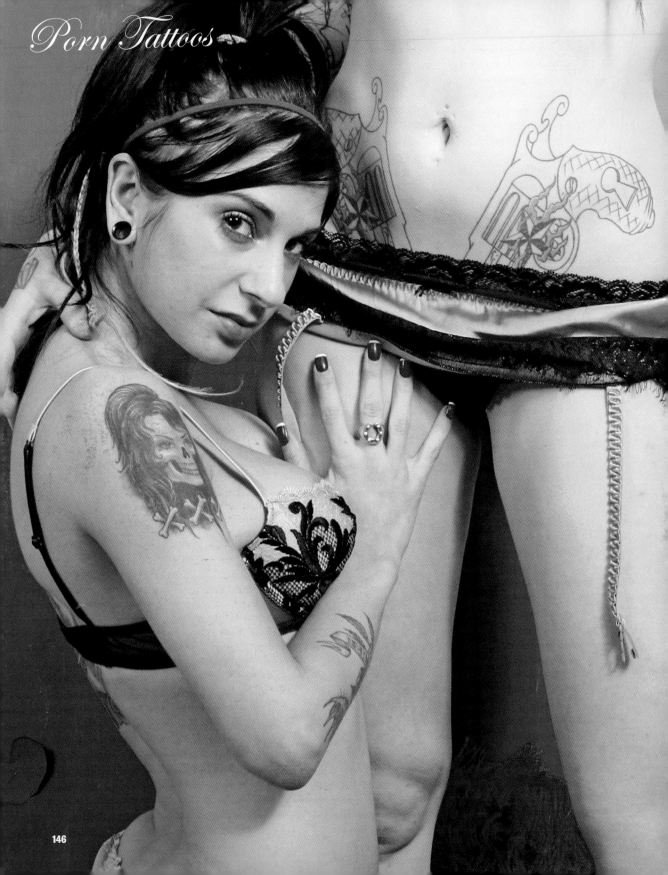

Inked
ANGELS

TATTOOED GIRLS ARE THE HOTTEST THING IN PORN. MEET JOANNA ANGEL, QUEEN OF THE PAINTED LADIES

WORDS **JAMES DOORNE**

When I was growing up, porn meant middle-aged women with bouffant hair pretending to be cheerleaders, even though the last time they went near a school was for parents' evening. Then the scene lurched to blondes with massive, rock-hard tits and lots of high-end production values, artistic pretence and 'celebrity porn stars'. It was like no-one ever thought that adding some fun would be a good idea.

Fortunately, the industry eventually got back on track and people started making cool porn for cool people. Tattoos, rather than stopping you getting work, made you a bankable asset. And we're not talking tiny dolphins jumping over globes or 'baby doll' tattooed on your hip. You didn't need ostrich-egg-sized implants either. And piercings were fine as well. Finally, punk rock porn had been born.

Joanna Angel is one of the most influential people on that scene. She founded Burning Angel in 2002, and couldn't be further from the porn star stereotype of blonde and dumb. A former dancer and alt.porn star, Joanna started Burning Angel after she left university with a BA in English Literature.

Joanna has written, produced, directed and starred in movies such as *Neu Wave Hookers*, *The XXXorcist*, the *Cum On My Tattoo* series, and the horror-porn HP Lovecraft parody *Re-Penetrator* that was deemed too controversial for American servers and is currently hosted abroad.

In 2006 Joanna was nominated for Adult Video News Awards in the Best New Starlet and Best Actress categories. She didn't win either, but she did go home with the award for Most Outrageous Sex Scene for *Re-Penetrator*.

We asked Joanna to send us some pictures of herself and her hottest employees to offset the inevitable sadness of reaching the end of this book. Turn the page to see what filth she sent us. ➡

Joanna's company website is Burningangel.com, and her website is Joannaangel.com

SALI

Sali is 23 and comes from the Washington DC area. She has 10 tattoos and a pierced tongue, and likes eating "pills and whiskey". Her first sexual encounter was on a bunk bed, and her best was "in a bomb shelter". She lists her hidden talent as "knife fighting", and she can also play slide guitar, apparently.

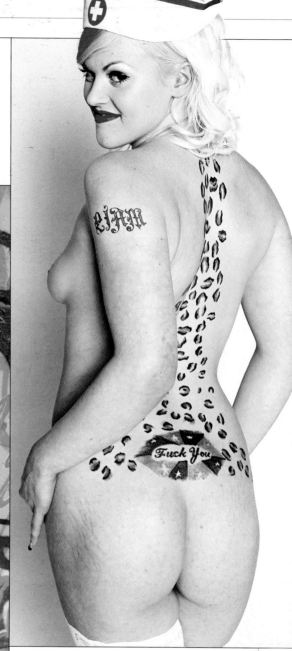

JADE

Jade is 19 years old and a Scorpio. She hails from "the sticks" of Philadelphia, and has a leopard print tattoo running down her spine. She can play the harmonica, and says her worst sexual experience was a toss-up between "the first time" and "that time in Cuba with the priest and a monkey".

ADAHLIA

Nineteen-year-old Adahlia is from Oakland, California. She has tattoos by Devon Blood and Matt Howse from Sacred Tattoo in Oakland, Jason McAffe from Temple Tattoo in Oakland, and Yutaro Sakai from Art Work Rebels in San Francisco.

She likes eating "uncooked sea creatures, foie gras, lots of rich, spreadable cheese, and rose petal ice-cream", and says of her first time, "He kept all his clothes on and his friends took a picture."

VENDETTA

Vendetta is 25 years old and has extensive tattoo work on her arms, back, hands, feet and chest, as well as double-nostril and double-lip piercings. Her favourite tattoo is the "pin-up girl serving brains on my forearm".

Talking about the best sex she's ever had, Vendetta says: "I have two uteri, and I was still a virgin on the left-hand side. But recently I gave my left-sided virginity to my boyfriend and I came for, like, five minutes straight. It was really intense."

Della Luce

TATT FACT

In 787 AD, a council of Christian churches renounced all forms of tattooing. Since then, getting inked has been frowned upon by the Church

PIXIE PEARL

Pixie is 21 and comes from NYC. She designed her "full-back pixie wings" tattoo herself, and also has the word 'lovecat' inked on her wrist. Pixie lives on a diet of ice-cream sandwiches, and she also likes bad slasher movies and *Star Wars*. Her hidden talent is "creepy double-jointed shoulders", and she once told Eddie Izzard she'd like to fuck him. He was busy. And her best time? "On a fire escape. With a strap-on." Ⓑ

KYLEE

Kylee is 21, comes from New York and is a Virgo. Her best sex was on the roof of her friend's loft building at 3am ("He bent me over the side of the wall and I could see down eight floors," she says). Kylee's hidden talent is that she can "swing on a pole like nobody's business" and can put both her legs behind her head.

151

INVISIBLE INK

SO YOU WANT A TATTOO BUT AREN'T SURE ABOUT LIVING WITH THE DESIGN FOR THE REST OF YOUR LIFE? THEN A UV TATTOO COULD BE JUST THE TICKET...

For many people, the thought of seeing the same tattoo under their skin for the rest of their life is enough to keep them ink-free. But for anyone who wants to dabble in body art without the risk of choosing a design they might grow out of in a matter of weeks, ultraviolet tattoos are the perfect solution.

Created using the same process as a normal tattoo, only using special UV-sensitive ink, a UV tattoo can only be seen under ultraviolet light – also known as black light, often used in nightclubs and in some public toilets to deter intravenous drug use – and is the closest thing to having a tattoo you can turn on and off.

Richie, of the Electric Soul tattoo parlour in Lancaster, California, is responsible for the gleaming designs you see here. "It really trips out people who've never seen a UV tattoo before," he says.

Of course, a UV tattoo doesn't quite match the big 'Fuck you, this is me, take me or leave me!' that comes with getting a regular tattoo – it's to real tattooing what paintballing is to going to war – but it's better than nothing. And it could satisfy your need to be inked without a lifetime of long sleeves at Christmas and family gatherings.

Although you can see the outline of the tattoo under normal conditions for the first few months after getting the work done, according to Richie a UV tattoo fades to invisibility: "The white or clear ink is totally invisible in normal light once the scarring heals after 12 to 18 months."

Richie recently moved to Colorado to work at The American Tattoo Society, but will still guest spot at Electric Soul. Ⓑ

For more on Richie's work, check out his website at Thedungeoninc.com

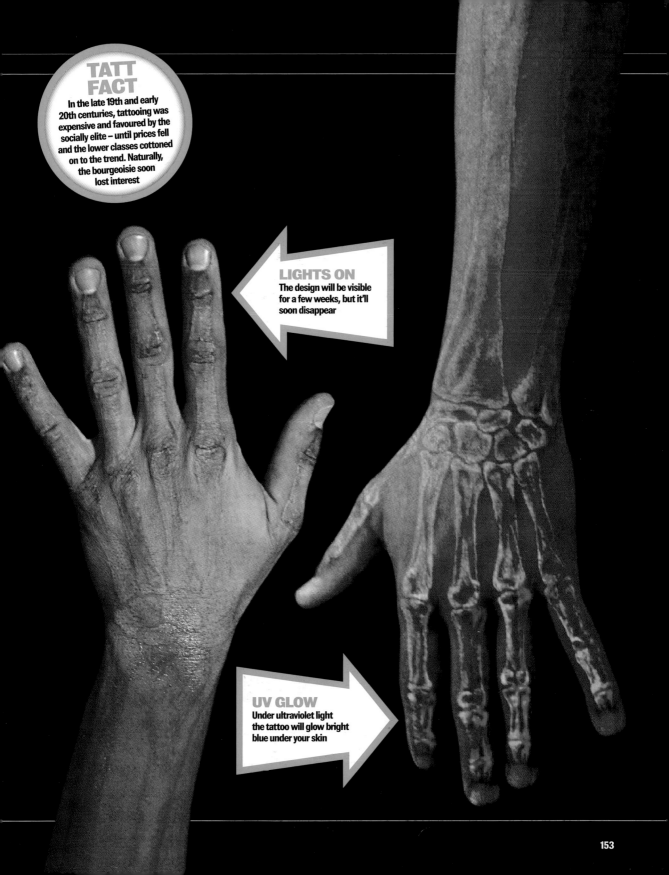

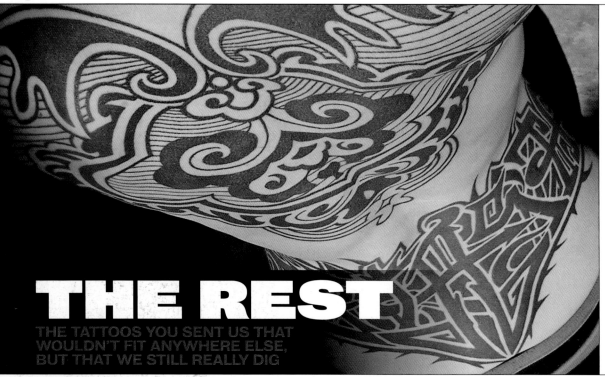

THE REST

THE TATTOOS YOU SENT US THAT WOULDN'T FIT ANYWHERE ELSE, BUT THAT WE STILL REALLY DIG

ZOE BAKER

Who did it? Sarah Street at Mantra Tattoo, Cheltenham, UK.

How do you feel about it now? I'd hate to be without this tattoo or the rest of my colourful skin, and I think of my ink as an ongoing art project. I'm far from done, so watch this space!

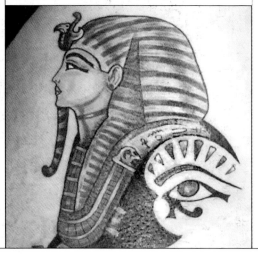

BLAINE TAYLOR

Who did it? Chris Bettly at Big Rapids, Missouri, USA.

Why did you choose it? Because I'm religious, but with a dark side. It means that I shouldn't judge people. You never know what a person is really like until you get to know them, and I'll never say that I'm better or worse than anyone else.

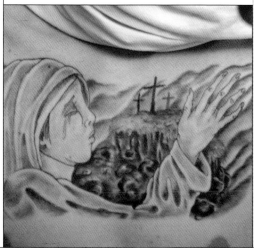

DAISY CUTTER

Who did it?
Roy Priestley at Skinshokz, Wyke, UK.
What is it? Old-school brass knuckles.
Why did you choose it? My husband
has a matching design, but in a different style.
How do you feel about it now?
It fucking hurt, but I love it!

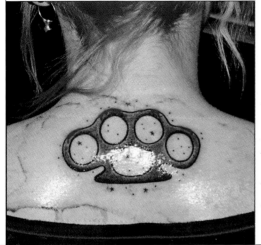

MARK REMNANT

Who did it? Amanda West at
Alzone Tattoos, Gloucester, UK.
Why did you choose it? I wanted
a theme running from warm colours at
the top of my arm down to colder blues at the bottom.
How do you feel about it now? Very happy. Feedback
is positive, but with a few exceptions!

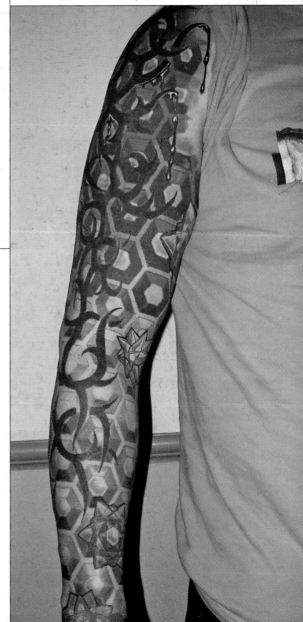

KRUELLA

Who did it?
Glen at New Image, Dinnington, UK.
What is it? Ivy vines.
Why did you choose it?
I wanted a big design, Glen drew this up and I loved it.
How do you feel about it now? Still loving it. It's like
a family vine with my family names integrated into it.

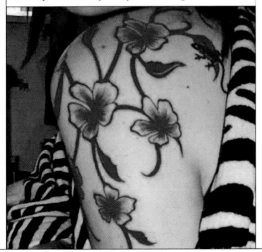

BRANDON SCHULTZ

Who did it?
Kyle at CM Tattoo, Costa Mesa, USA.
What is it? The artwork came from
an instruction booklet from an old set
of headphones. Above the design it says, "In 1984,
life is good", which is a reference to Orwell's novel
and also the year I was born.

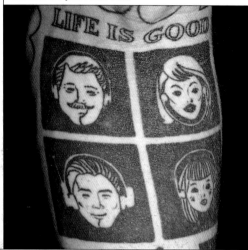

REAL LOW CLASS

Who did it? Dan Dittmer at Electric
Dragonland Tattoo, Minnesota, USA.
Why did you choose it?
I wanted to draw a bad ass skull,
but I can't draw. So it ended up like this.
How do you feel about it now?
I barely notice it.

ANDY GIDDY

Who did it? Troy Bond at High Class
Tattoos, Torquay, UK.
What is it? Black and grey naked ladies.
Why did you choose it?
Because I like black and grey naked ladies.
How do you feel about it now?
Fuckin' nuts about it, like I am with all my tattoos.

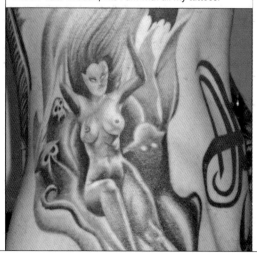

NATASHA AKA NATAKA

Who did it? Rory Keating, previously at
Jade Tattoo & Piercing Studio but now
at Guru Tattoo, both in San Diego, USA.
Why did you choose it? They have various
influences; body armour, jewellery, corsets, belts…
What next? I'll be working on my legs, which will each
take about 100 hours to complete.

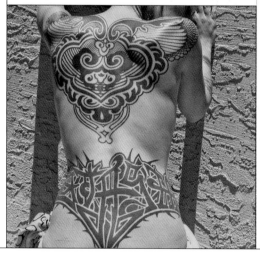

LESLEY DENT

Who did it?
Allan Lowther at North Side Tattooz, Whitley Bay, UK.
What is it? My left sleeve is dedicated to Las Vegas and celebrates my marriage. My armpit cherries are dedicated to the date itself. My right leg has three interwoven Alphonse Mucha pictures, and I also have a warrior queen on my back. And much more!

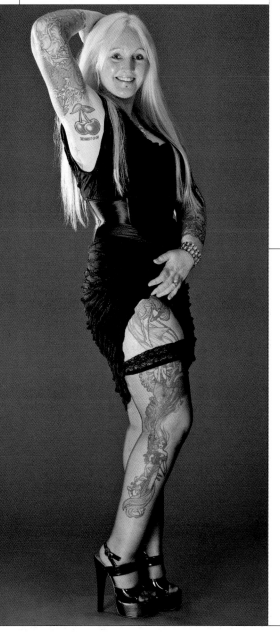

CANDICE BETTISON

Who did it? Andro at Haunted House Tattoos, London, UK.
What is it?
A maze of swastikas, the Japanese symbol for good luck, and a lotus flower.
Why did you choose it? I love swastikas, but for the good meaning they originally had.

LOKI

Who did it?
Brett at Vision Skin, Brisbane, Australia.
What is it?
Dante's Inferno – 27 levels of hell.
Why did you choose it? I like idea that, even in hell, it's possible to get a second chance if you're willing. And I now have a map to get out!

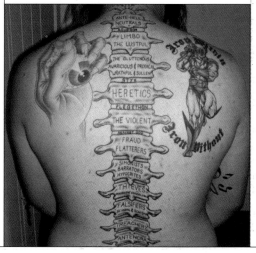

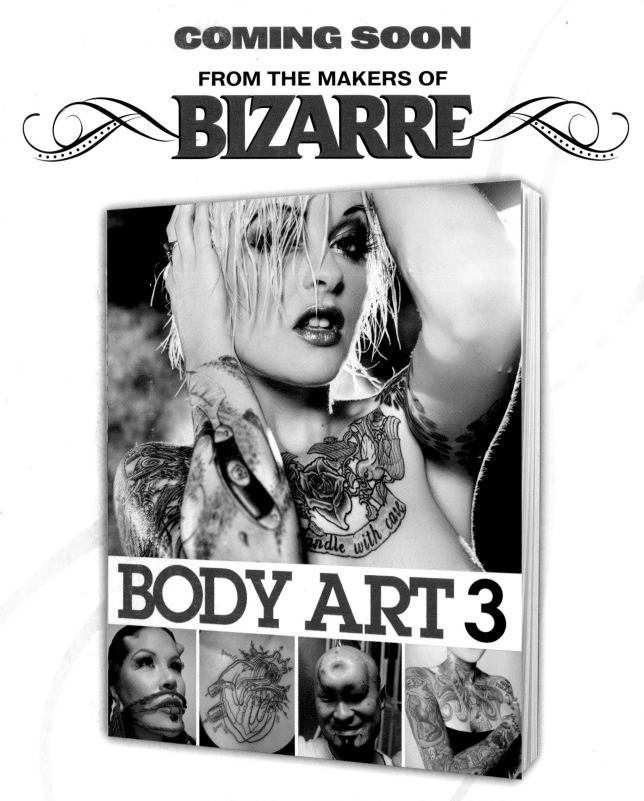